T0386520

Dzhangal

Dzhangal
Gideon Mendel

GOST

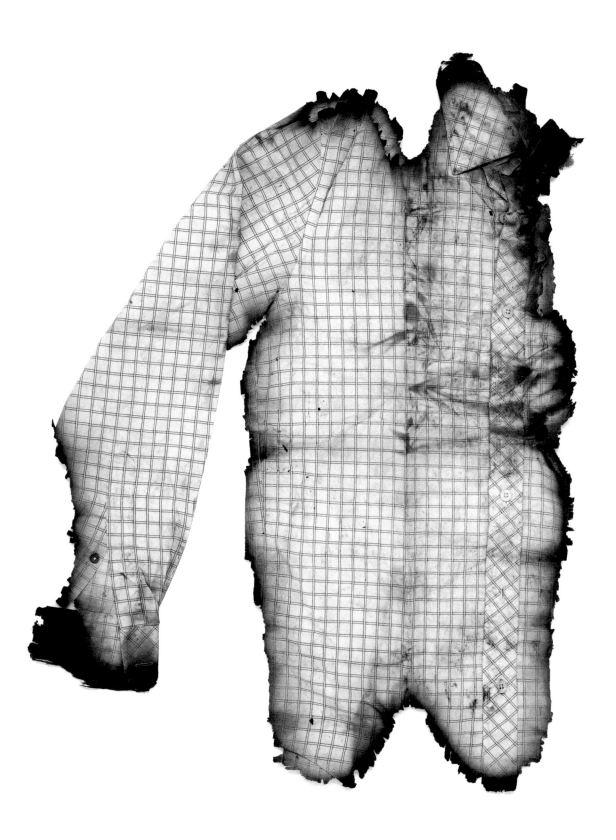

Check shirt Collected 15 September 2016

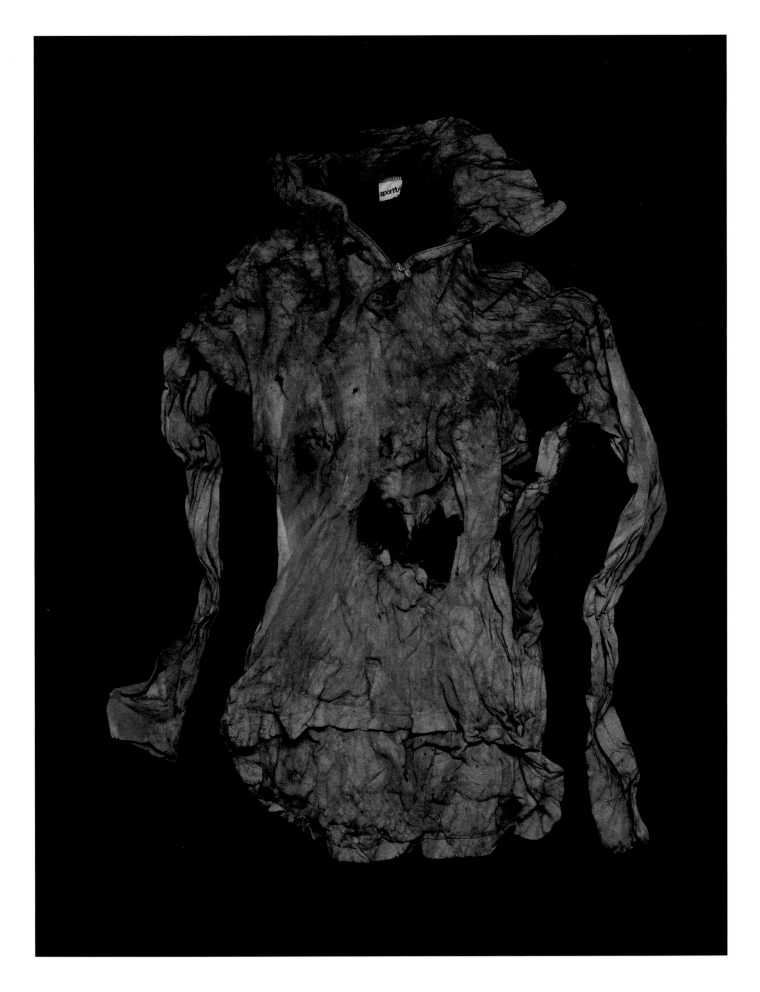

Sportful fleece Collected 15 September 2016

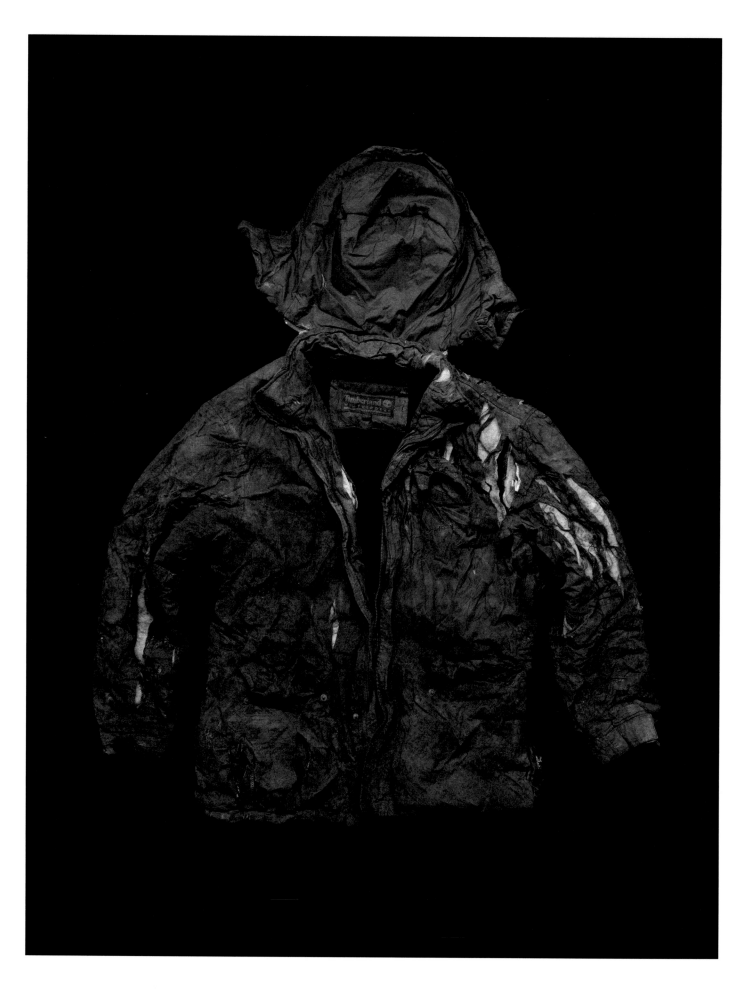

Timberland jacket Collected 15 September 2016

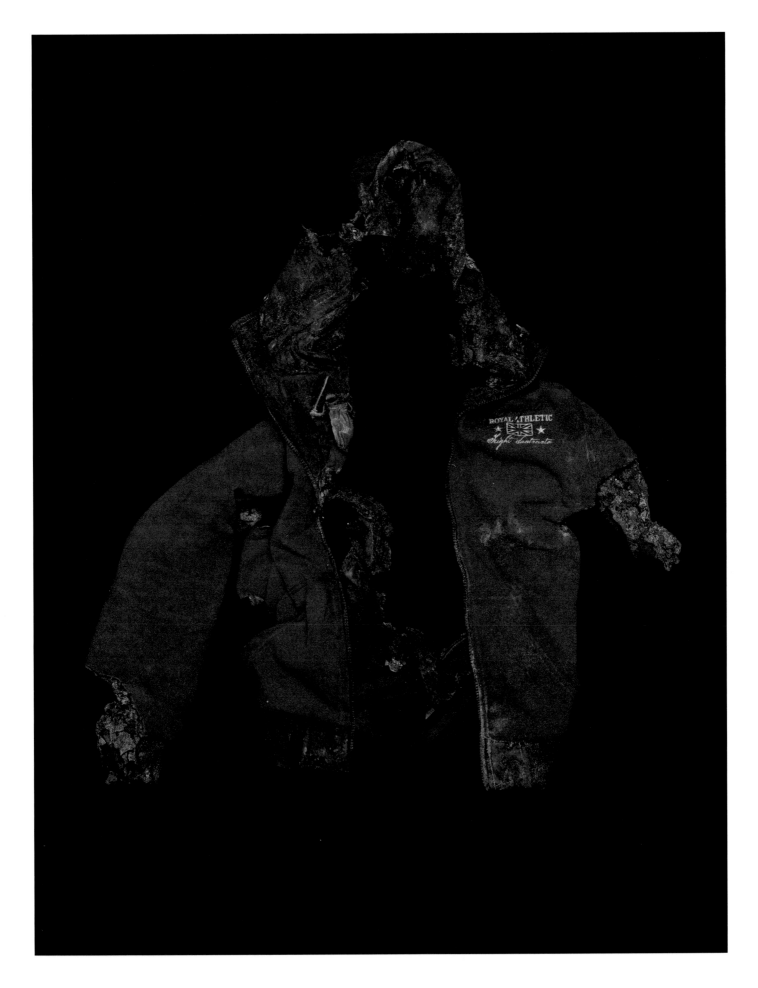

Navigator Royal Athletic fleece Collected 27 October 2016

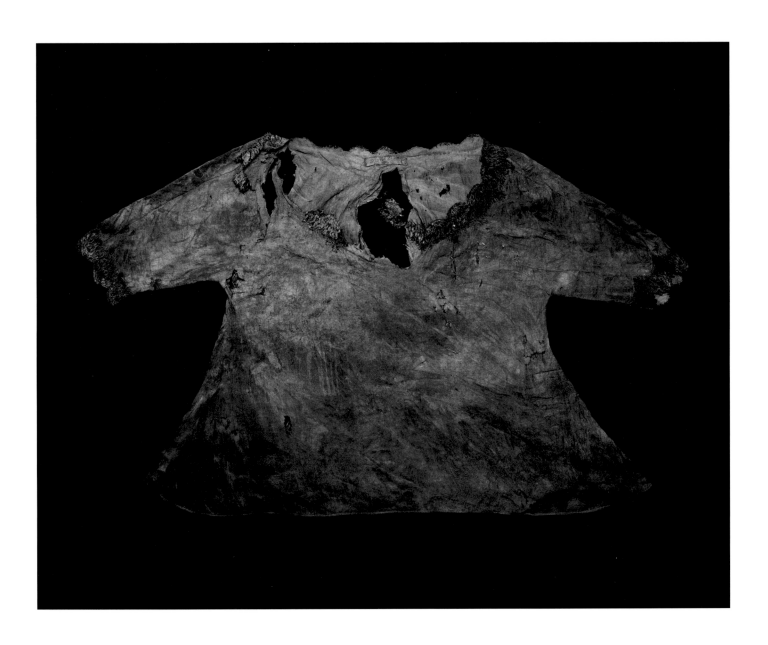

Smock top with lace trim Collected 15 September 2016

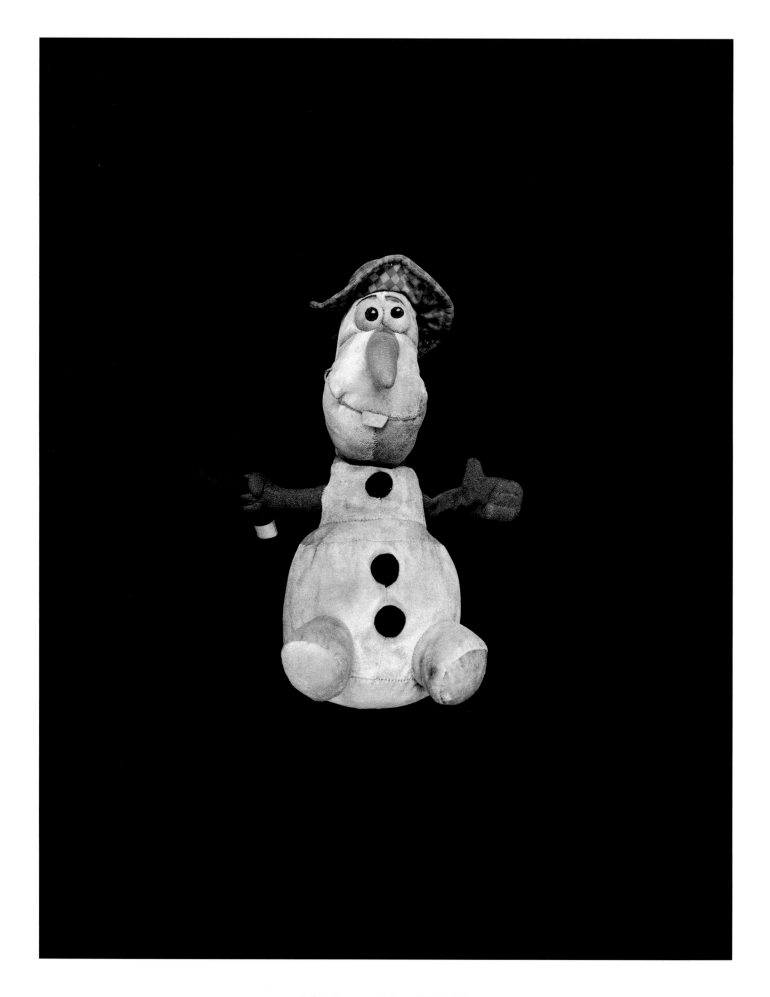

Olaf the Snowman Collected 21 May 2016

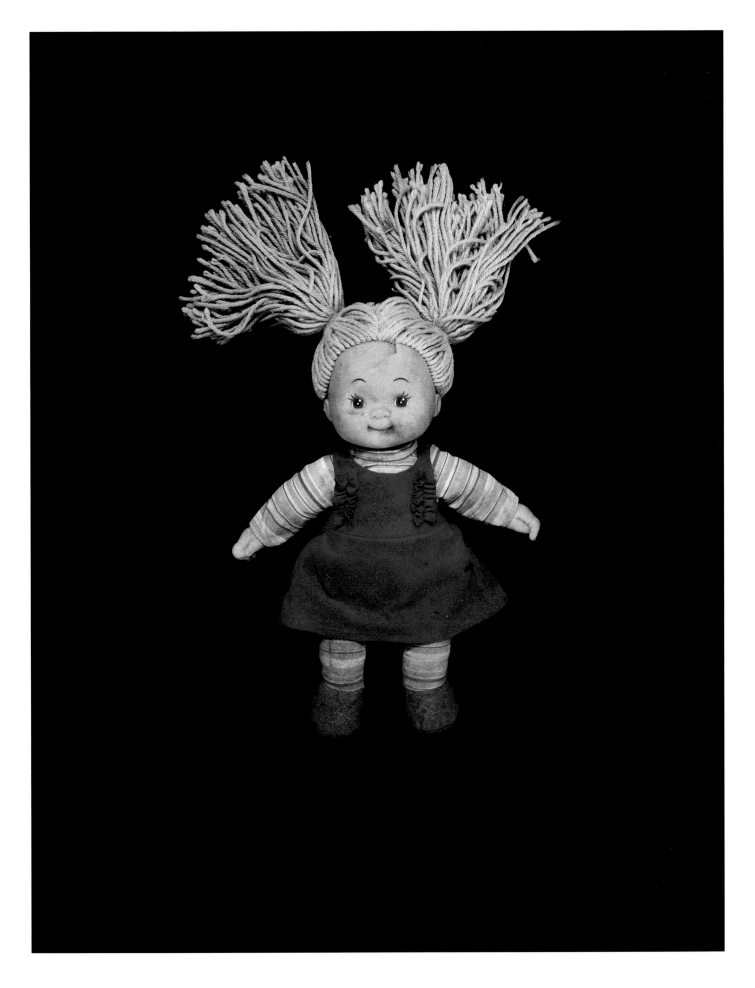

Fabric doll with vinyl face Collected 21 May 2016

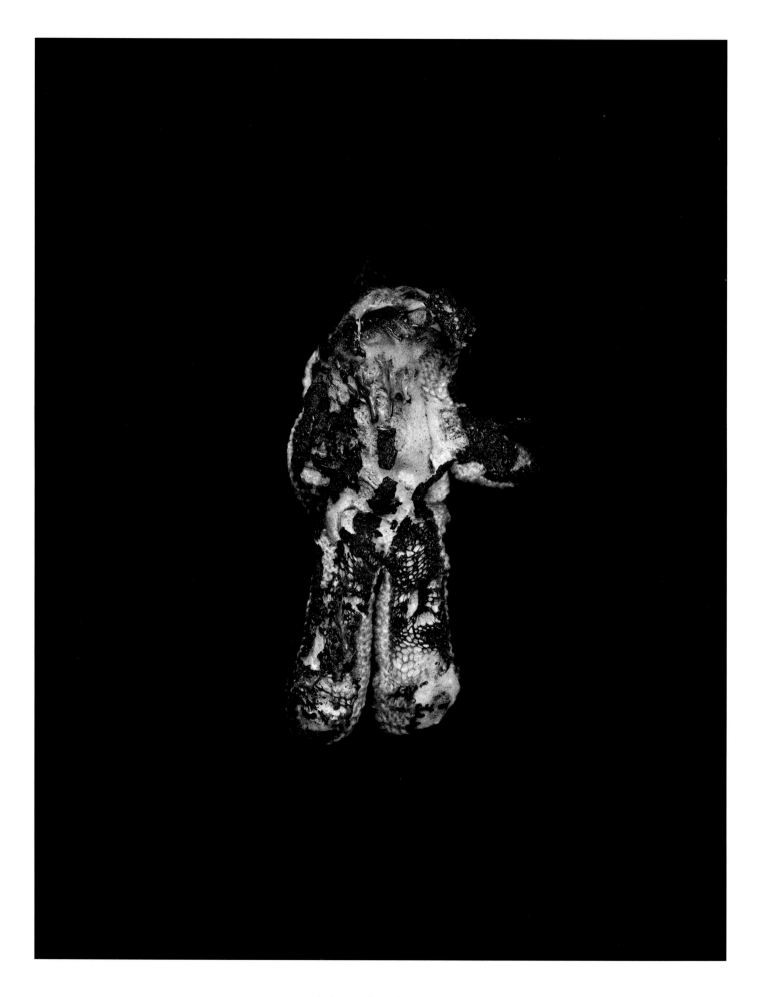

Knitted soft toy Collected 28 October 2016

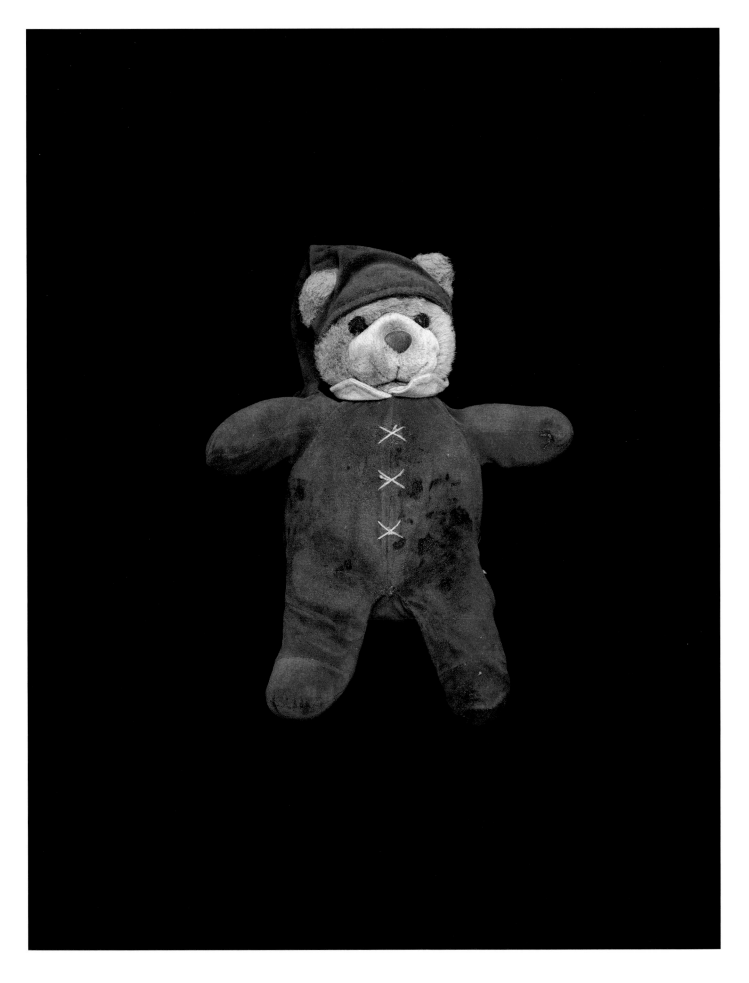

Teddy in pyjamas Collected 27 October 2016

Account by 'Africa'

One day, someone was knocking on my door. I went to open it, to welcome maybe a friend, something like that. But when I opened my door, someone covered my face. After that, four or five others put me in a pickup. They drove for maybe 15 minutes. After that they came for me, and I went into a room, three by four metres. You can't see anything in this room. You could just hear some screaming. For maybe two days, I didn't know why I was there or where I was exactly. I had no idea whether it was really night or when it was morning, I was not able to tell exactly the time.

I went to my auntie who lives far away from my place, like three to five hours. I rented a car to take me there, because I couldn't drive – my fingers were broken. I stayed for three days. My brother called me, told me, 'Don't come back. If you are already away, go, go. Find smugglers to help you go to Libya.' I chose to go to Libya. It took three months.

The aim was to get to Egypt, nothing more, nothing less. I didn't plan on coming to Europe – it wasn't a dream or anything. I just wanted to be somewhere safe, even if that was Egypt.

It was big trouble when I came here. I can't believe this is Europe. Is it true that this place exists in Europe? Where is humanity, where is democracy? I think, because we have come here, we are not human beings; we become animals, a new kind of animal. A new kind of animal that has developed at this time. It's known as 'refugee'.

I was in this wonderful world, the Jungle, for three months. Really, it is wonderful. Because of the people inside, they are wonderful. You can see many nations, saying, 'Hi, hello,' in different languages. You can see in their eyes that they respect you.

Someone sees someone who is cold. Maybe he will give you his blanket: 'Take this, you are colder than me.'

Now, I am living in a small city in Wales, waiting for my second interview. I am not allowed to work. I cannot volunteer formally unless a volunteer organisation writes a letter to the Home Office for me, to ask for permission. I do not want to do this; the Home Office might not like it.

When I am in the city centre, I take tea in a café run by Eritreans. Many Africans go there. I feel relaxed, because I do not experience racism there.

Waiting and doing nothing is hard – I like to be busy and to organise things. Sometimes I wish I was in the Jungle, my shining city. Conditions were very difficult, but I could do many things.

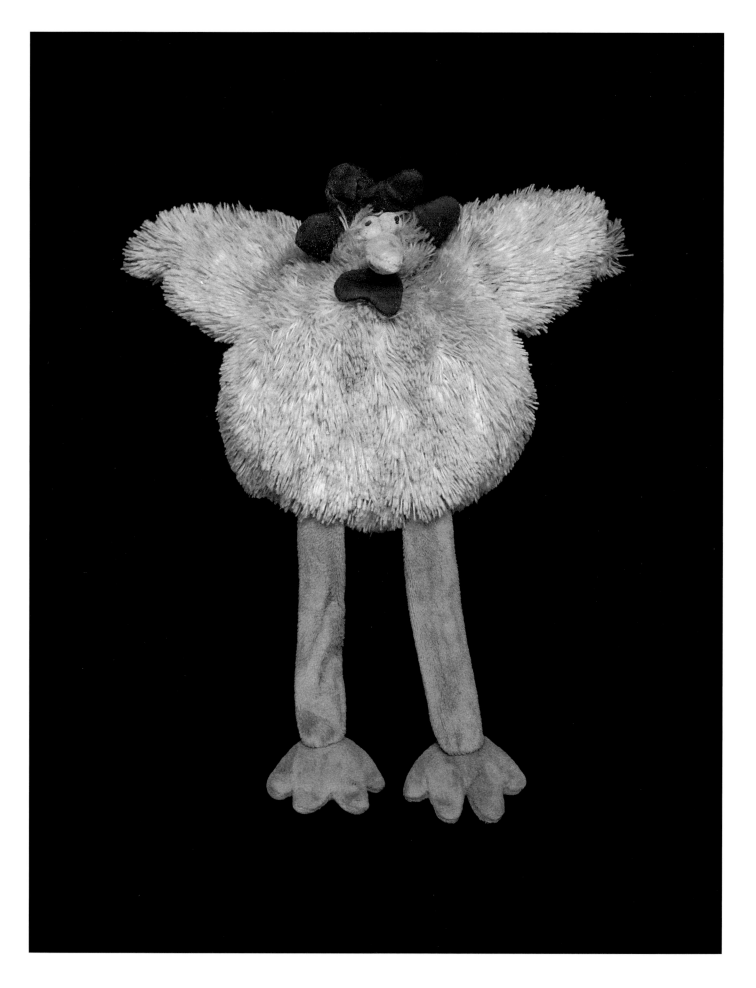

Chicken soft toy Collected 27 October 2016

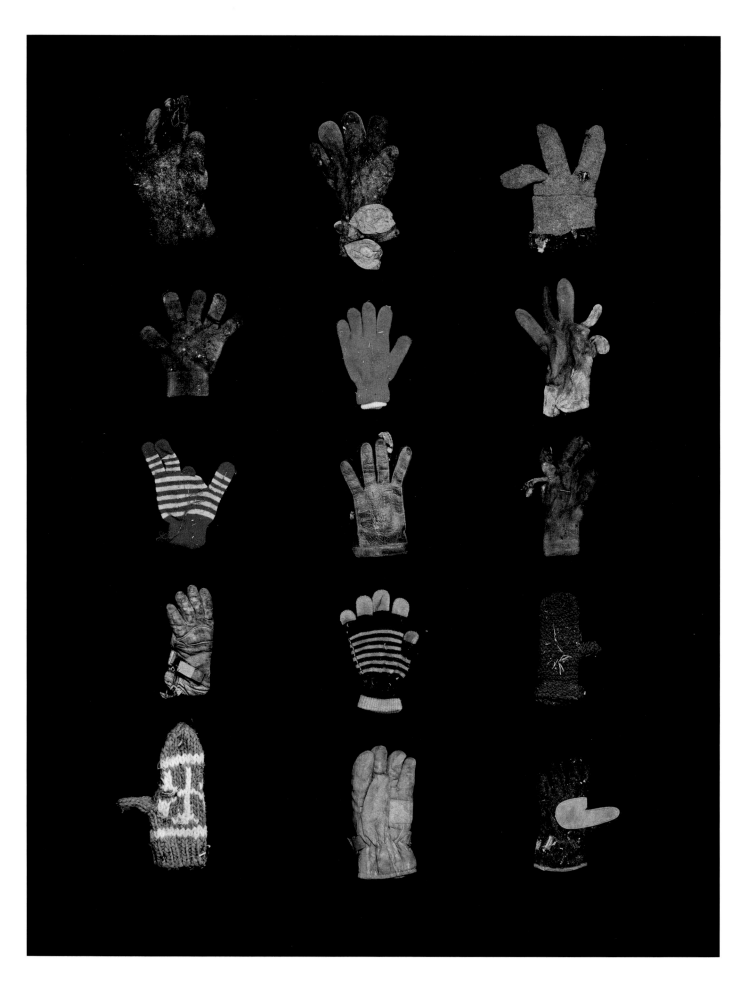

Fifteen gloves and mittens Collected 21 May 2016

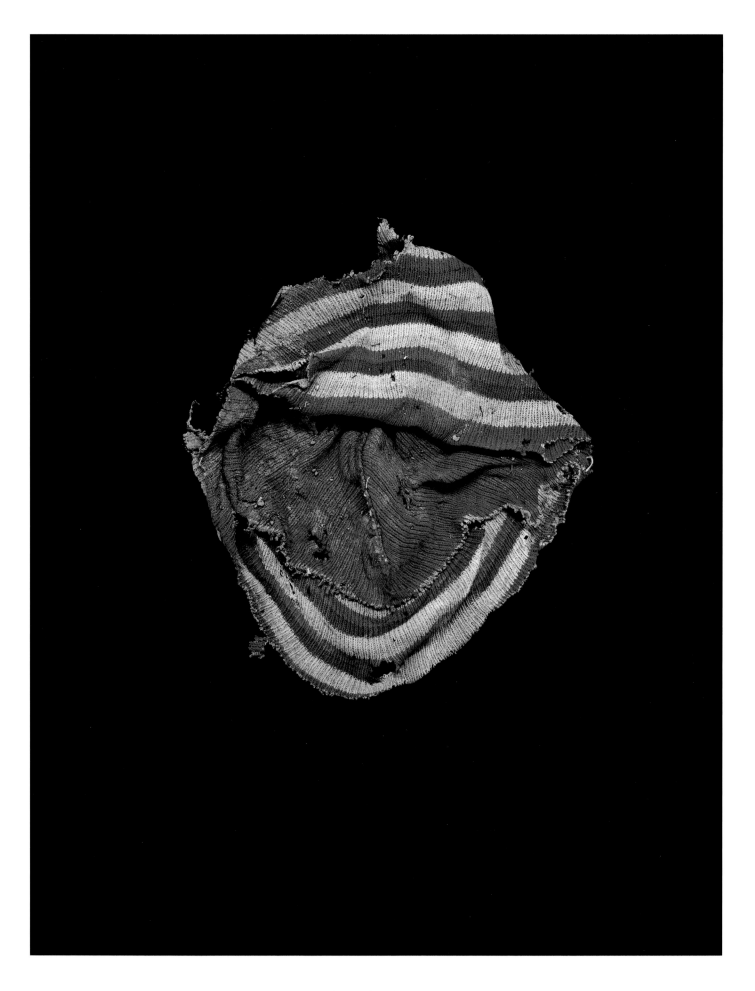

Knitted hat Collected 21 May 2016

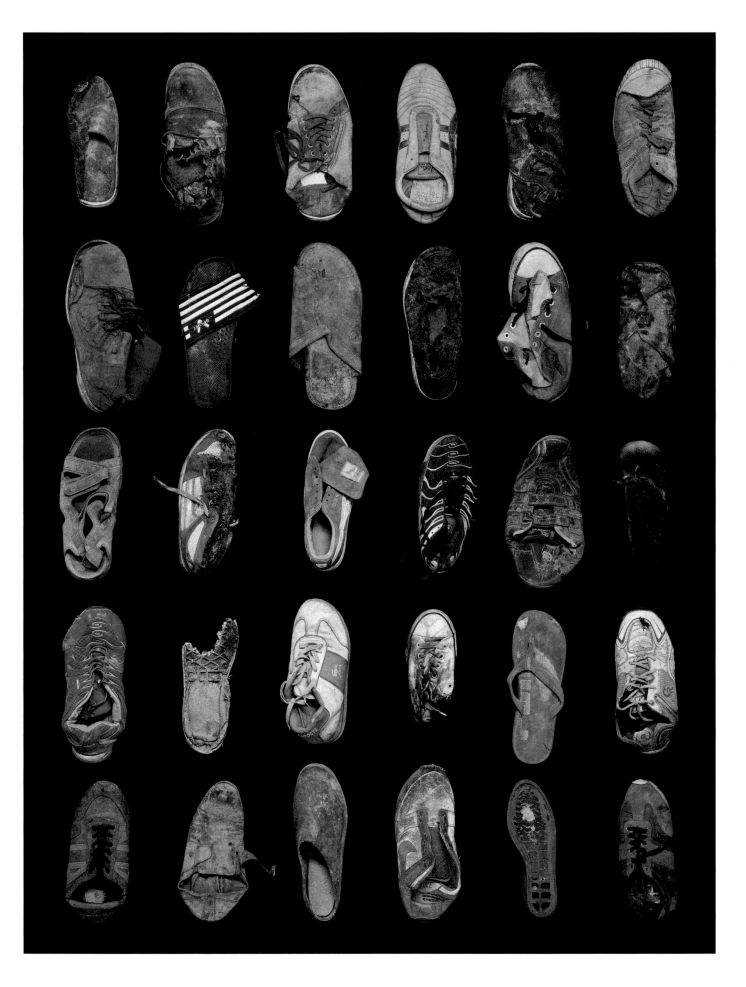

Thirty shoes, trainers and sandals Collected 21 May, 15 September, 27 October and 28 October 2016

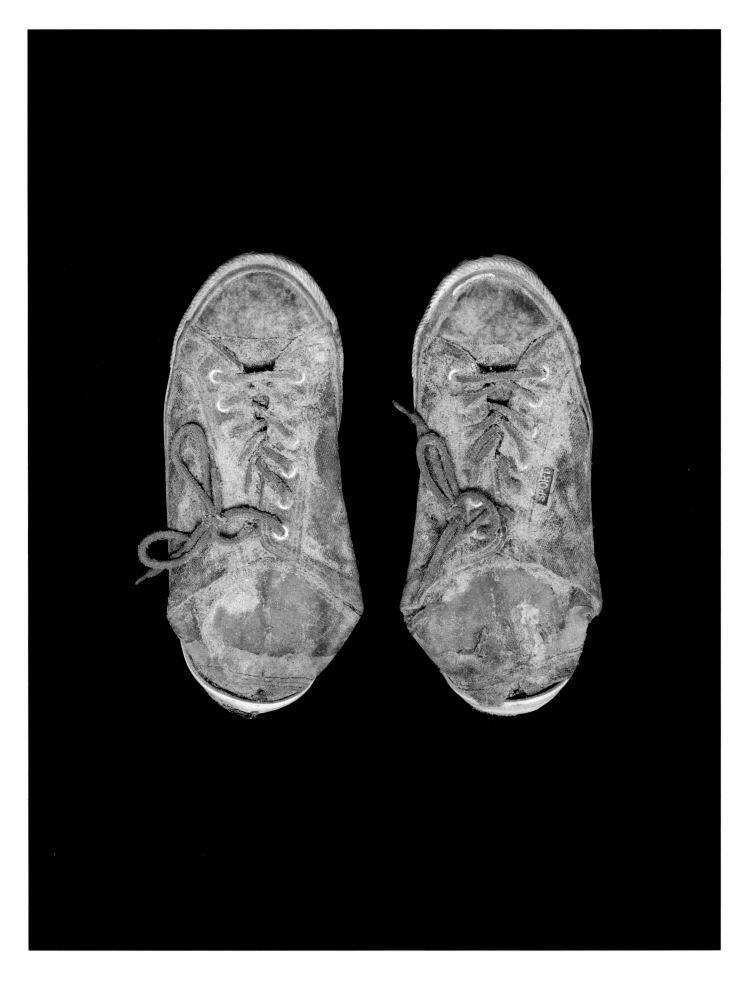

Pair of lace-up shoes Collected 27 October 2016

La Liberté guidant le peuple (1830) (3,25 × 2,60 mètres, musée du Louvre, Paris.)

1. La Liberté tenant le drapeau aux couleurs de 1789 (abandonné depuis 1815). 2. Un bourgeois ou un maître-artisan. 3. Un ouvrier ... manufacturés. 4. Un paysan ayant récemment migré en ville. 5. Un étudiant (polytechnicien). 6. Un « gamin de Paris » avec ... d'un soldat de Charles X et des pistolets de cavalerie. 7. Les cadavres de soldats de Charles X. 8. Notre-Dame de Paris.

ACTIVITÉ

DOCUMENT 4

1. De quelle révolution s'agit-il ? Quel monument prouve que l'on est à Paris ?

2. Que représente la femme au centre ? De quels symboles républicains est-elle munie (voir aussi doc. 3) ?

3. À sa droite, quelles sont les catégories sociales représentées ?

4. Quels objets l'enfant a-t-il arrachés aux soldats du roi Charles X ?

5. Comment est fabriquée la barricade ?

6. Quels éléments montrent la violence de la révolution ?

7. Quel est le sommet de la composition ?

8. Quel est le mouvement général des personnages ? Quelle conclusi... en tirer ?

Les regards → Le mouvement vers l'avant

composition du tableau

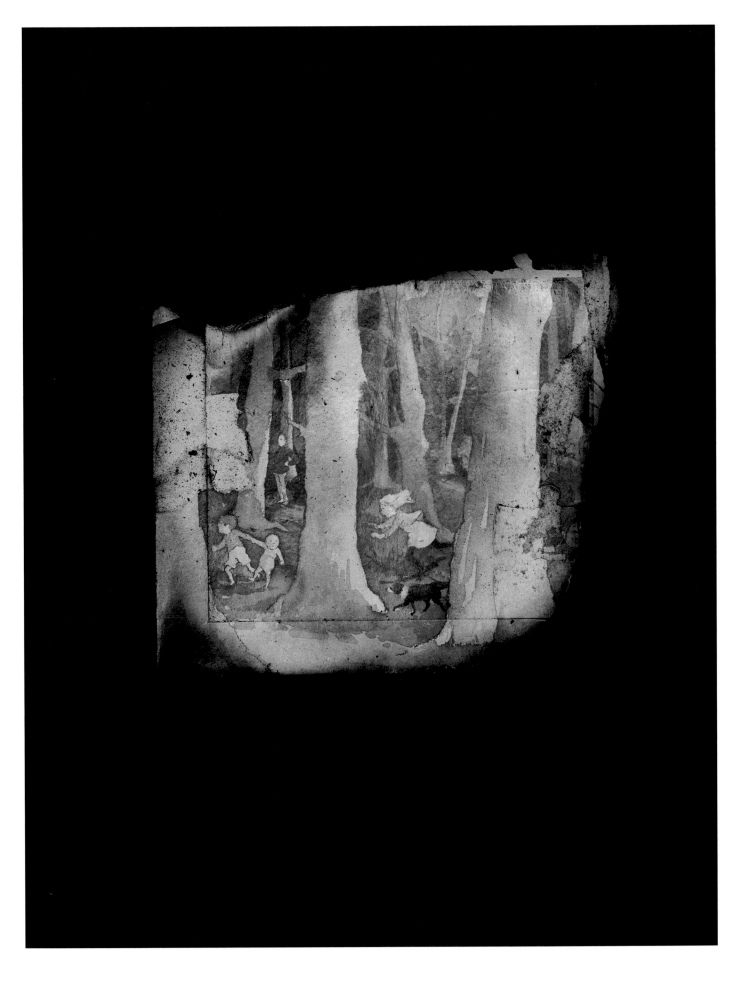

Page from children's book, 'We're Going on a Bear Hunt' Collected 28 October 2016

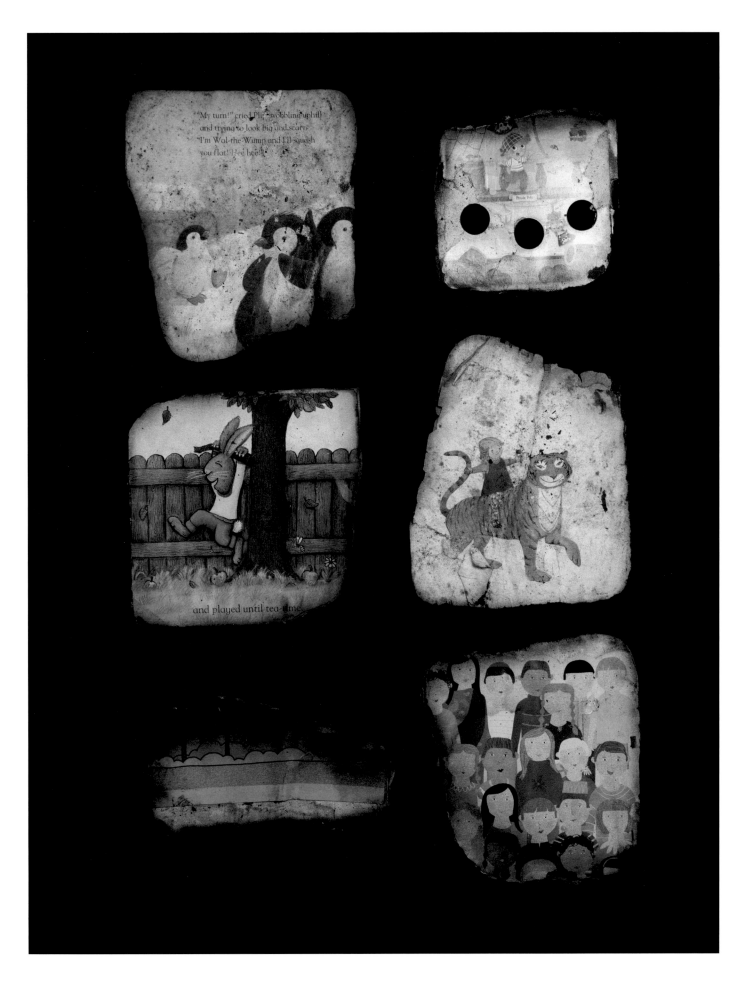

Pages from children's books Collected 28 October 2016

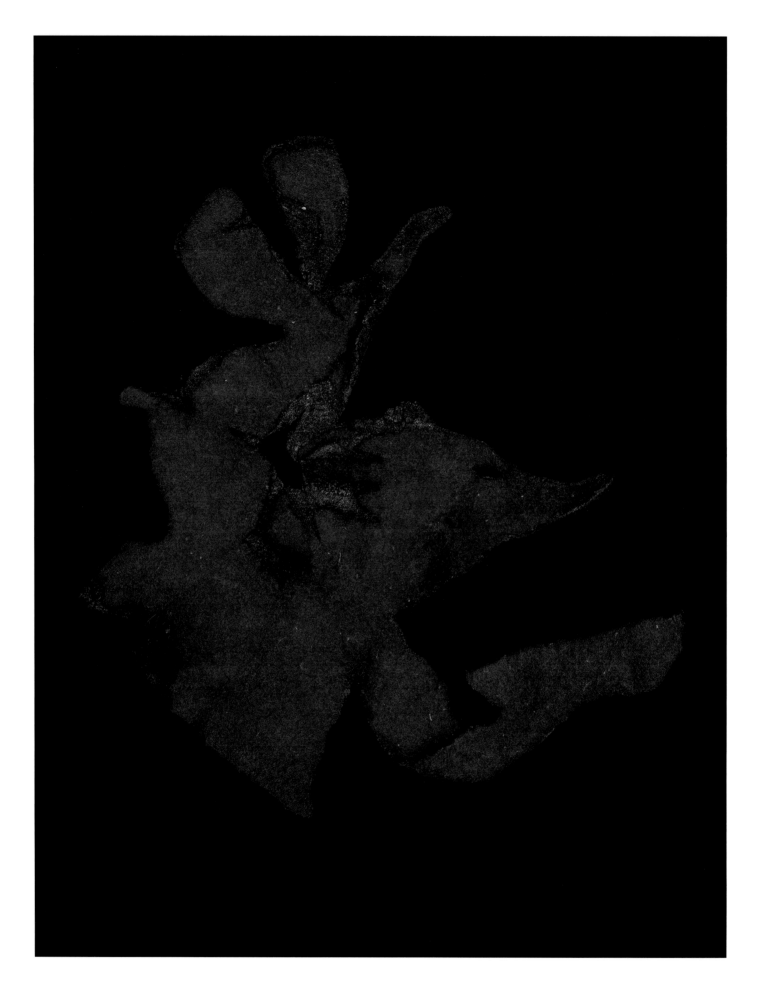

Blanket fragment Collected 27 October 2016

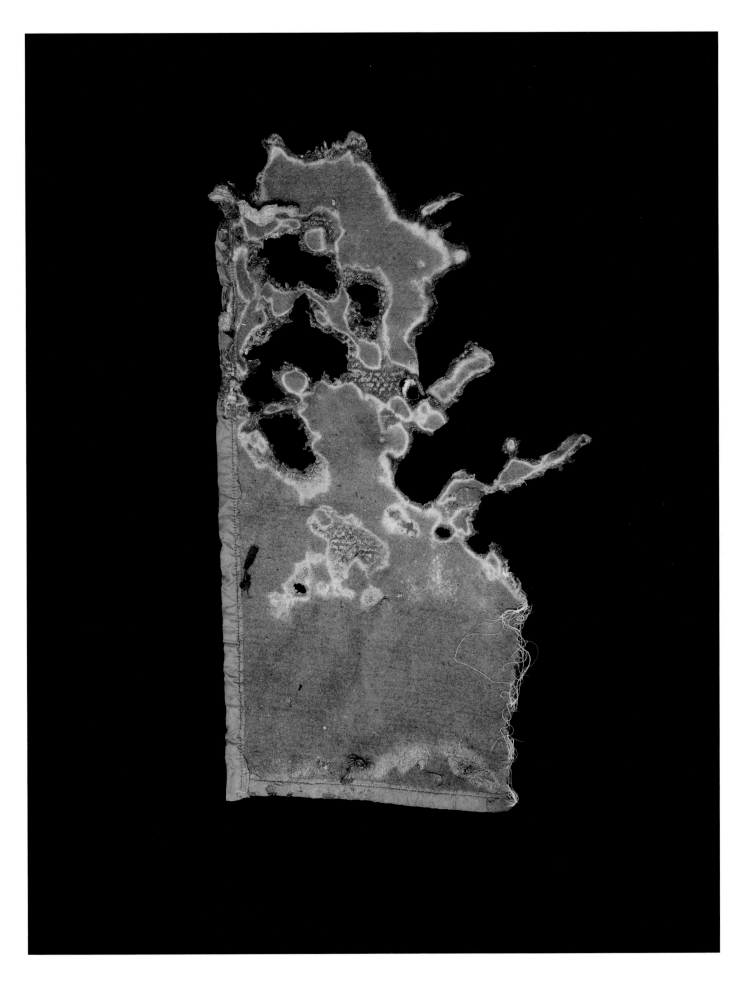

Blanket fragment Collected 27 October 2016

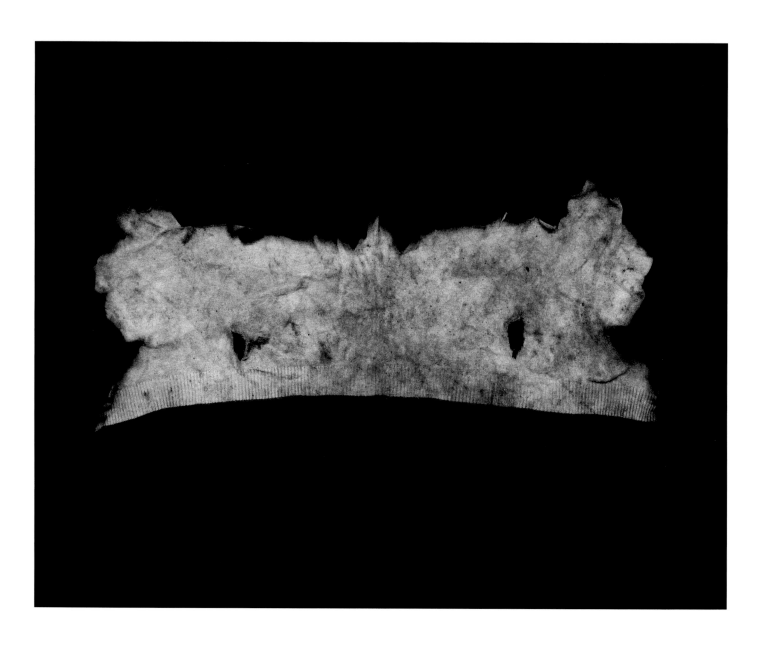

Ribbed section of knitwear Collected 15 September 2016

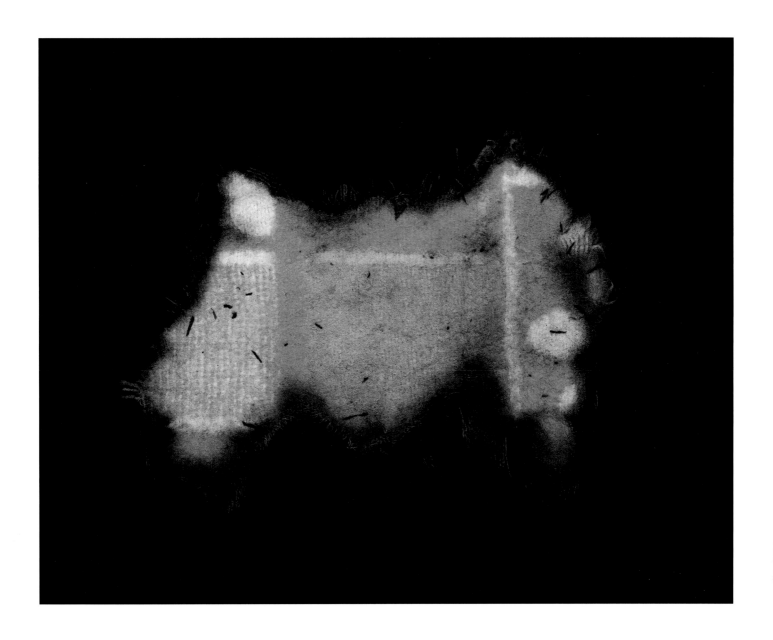

Blanket fragment Collected 15 September 2016

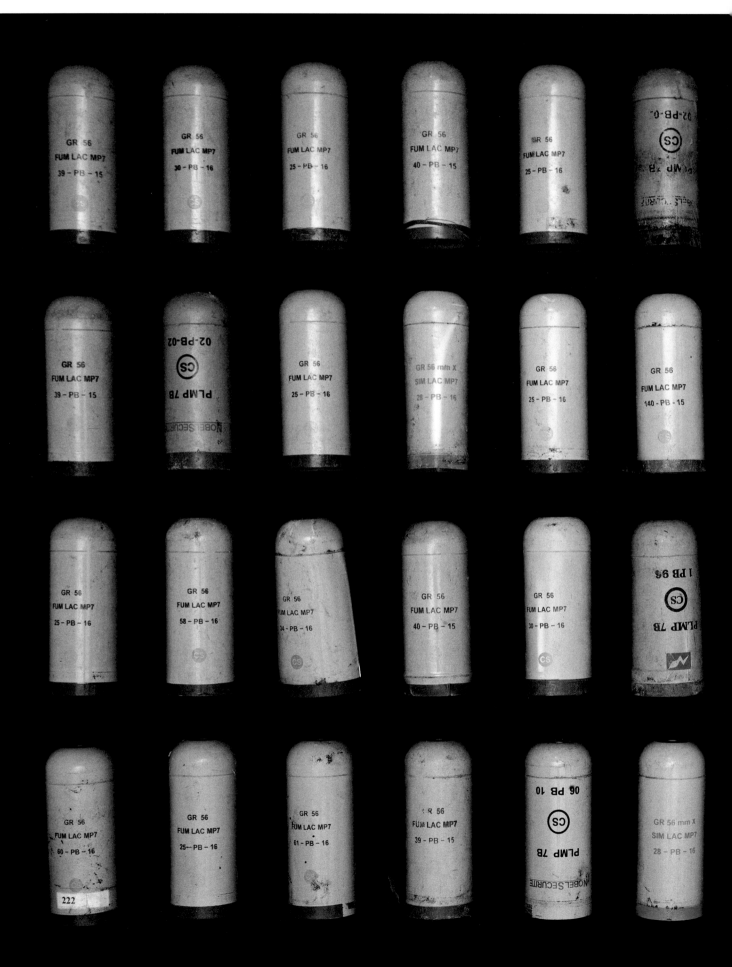

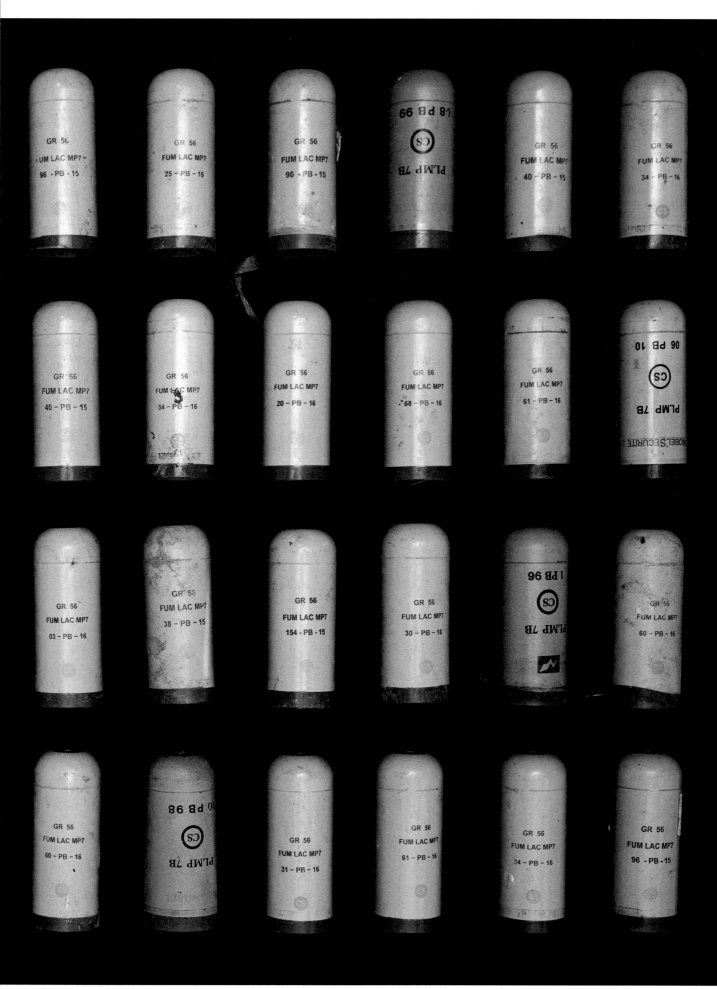

Previous spread
Forty-eight tear gas canisters Collected 21 May, 15 September, 27 October and 28 October 2016

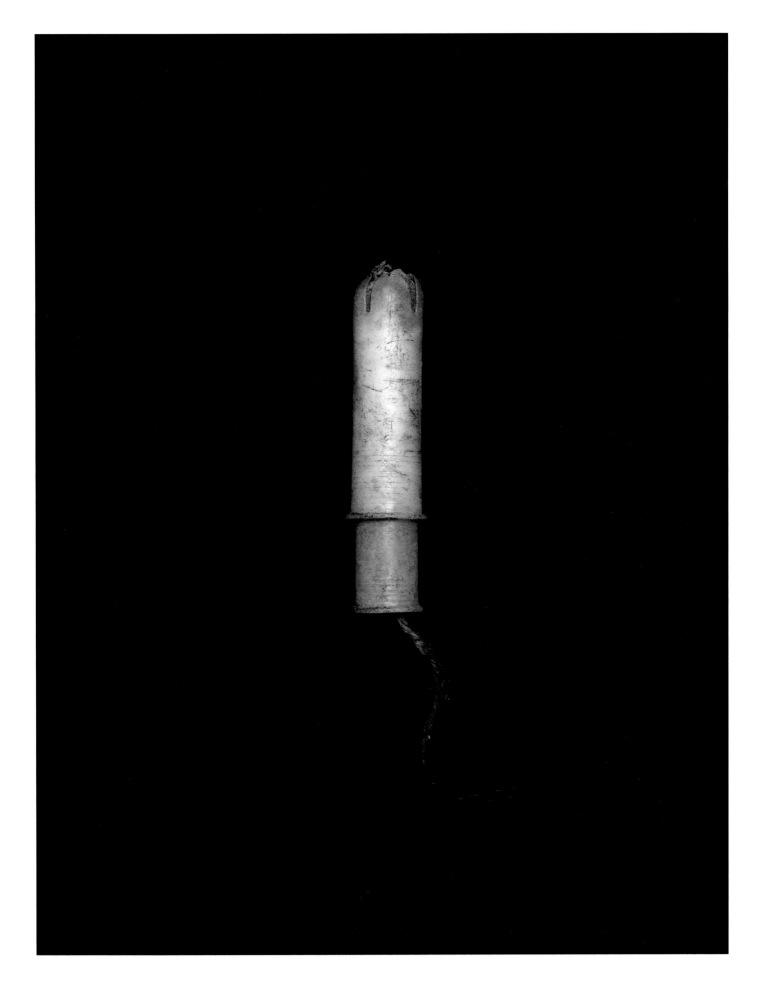

Tampon with applicator Collected 21 May 2016

Poetry by Babak Inaloo

Some thoughts are fighting in my head, like a war
of devils vs angels, like a war of my fists vs walls,
like a war of my hands vs the cold weather, like
a war of me and nostalgia, like a war of me and the
French language, like a war of me and strange looks,
like a war of my eyes and police eyes, like a war of
hands vs fences, like a war of nation vs government,
like a war of birds and borders.

Who knows what's at the end of this way?
Who knows how tired my legs are?
Who knows in this cold and dark Jungle how a warm
heart beats?
Who knows how many dreams will be killed in my
head at midnight?
And who knows with which dream I will wake up?
Who knows what's going on between me and my
friends in these containers?
Who knows with a beautiful rain how many people
will be cold?

And at the end of this one-way road, after all of these
green and dark ways, maybe at the last station, where
the sky and rail kiss each other, my mother will wait
for me with a beautiful flower, my father will invite
me for a hot tea and my brother and I will play as we
did in childhood in our yard.

So until my mother's flower is waiting for me,
while my father's tea is still hot and my brother's
game is not finished, I will walk.

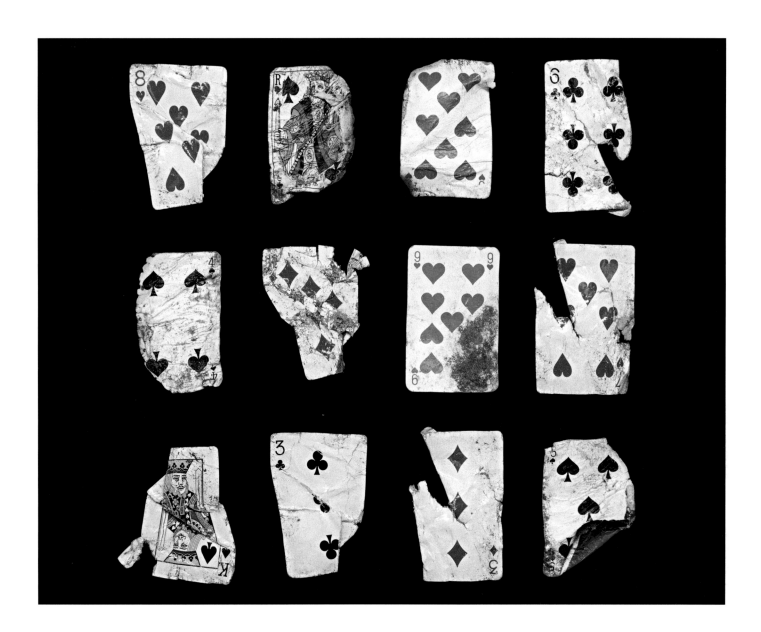

Twelve playing cards Collected 21 May 2016

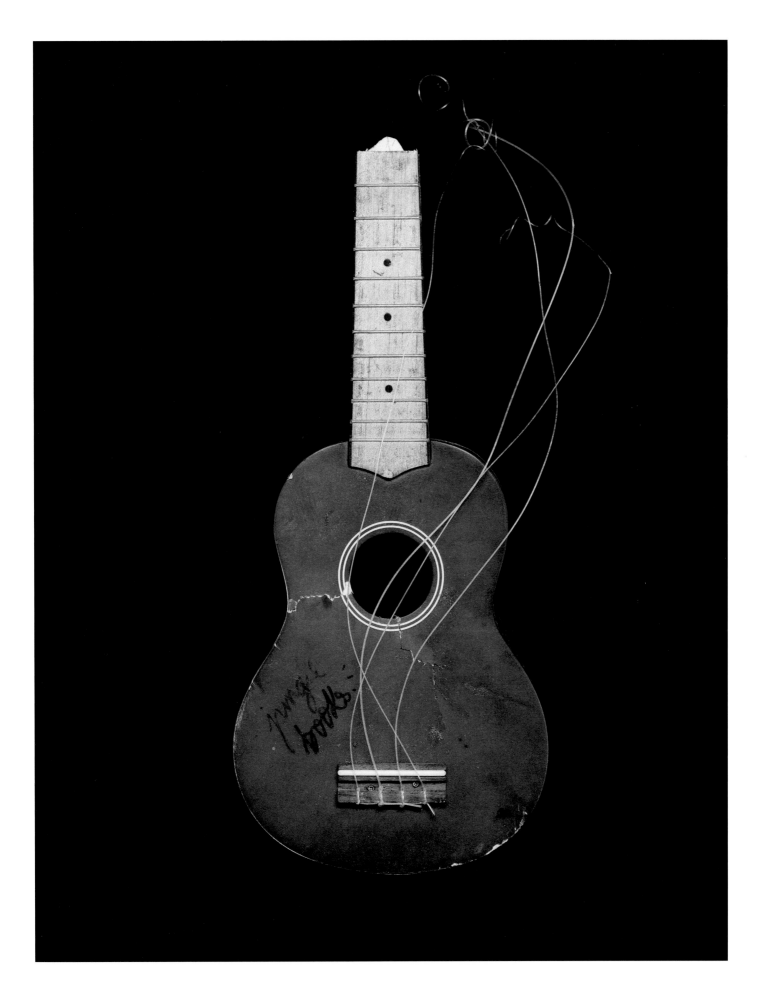

Toy musical instrument Collected 27 October 2016

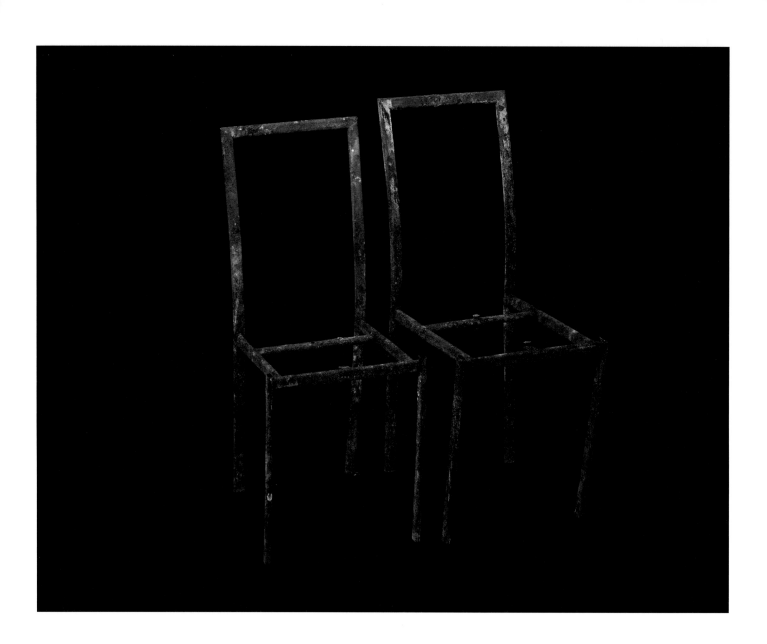

Metal chair frames Collected 28 October 2016

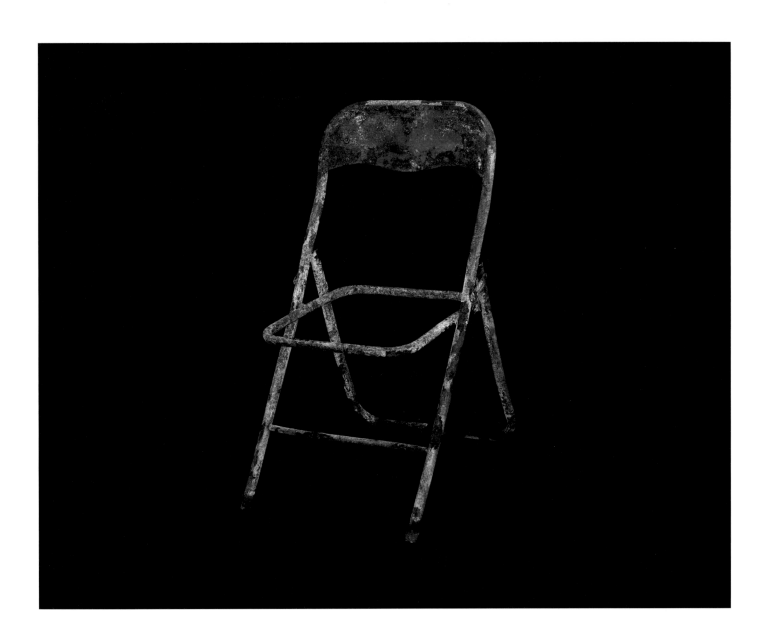

Folding chair Collected 28 October 2016

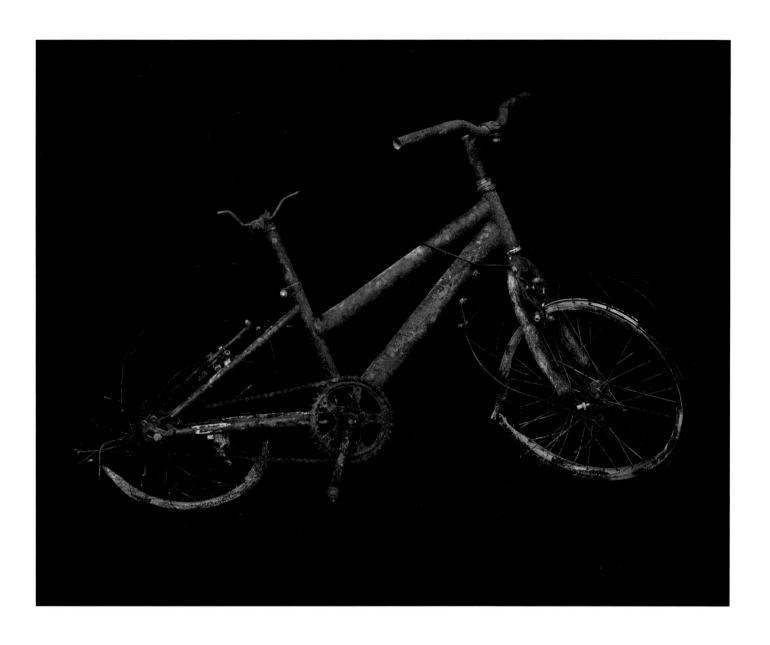

Children's bicycle Collected 28 October 2016

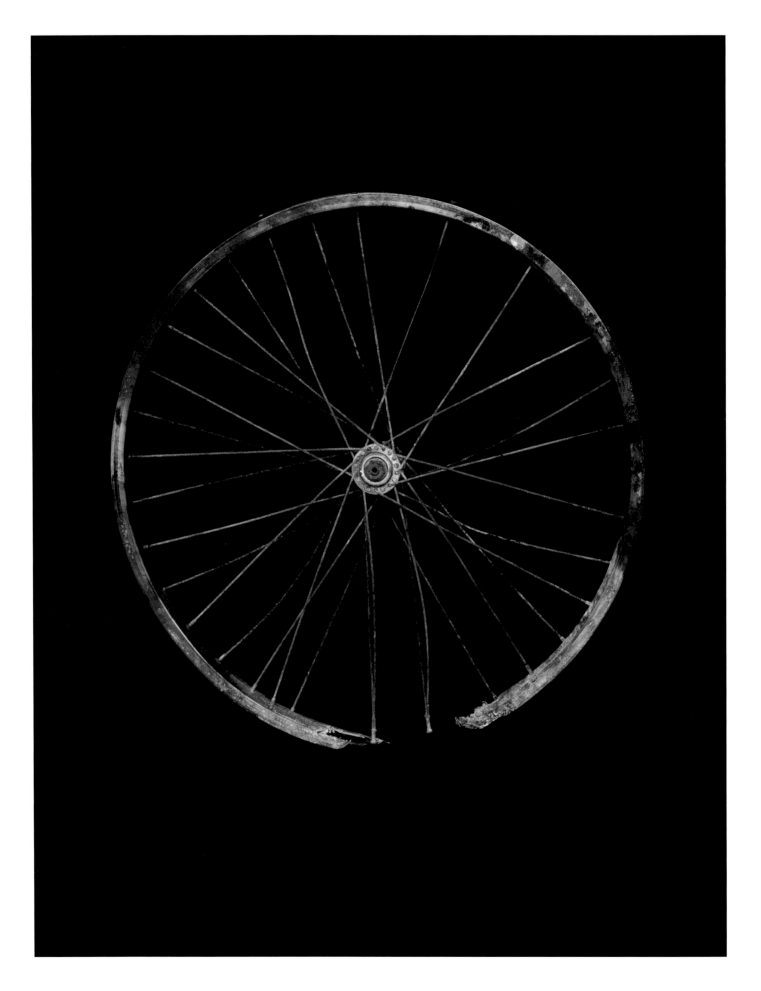

Bicycle wheel Collected 27 October 2016

Poetry by 'Mani'

Calais Jungle.
Dark is coming.
Day dies but life in the Jungle begins. I should be ready to go to try.
Majid told me, 'Hurry up. We have to be at seven in the Kurdish restaurant.'
The weather is still cold. I have to be wearing a lot and a lot.

Everywhere is full of rubbish, but we have to live between it.
Maybe because we made it ourselves, don't worry, after a period of time we are accustomed to it.

I try to see the sky when crossing through the rubbish.
But how can I cross it without looking at it?

I look at all my clothes.

I get all of them from the lines. Especially this jacket – when I achieved this, after more than one hour standing in the queue, I felt like a hunter come back home with a big hunt.

I think, 'Which English person was wearing this jacket before me? And was he more happy or the same as me?'

I come back from the try, sometimes at dawn,
After maybe five, six or more hours of walking, running and
Escaping from the police in the freezing weather.
Still the police gas in my chest.
Heavy steps.
I say to myself, 'Just, just one step.'
I cough and cough.
I see this street.
Finally, have I arrived in the Jungle?
I take a deep breath.
Yes.
My cold and wet shelter,
This is a palace in paradise for me,
A real palace.

Hamid speaks with his wife in Iran.
He shows himself as hopeful to her.
But me and the Afghan boy,

We know this is not true.
I hope she doesn't understand that Hamid is telling lies to her.

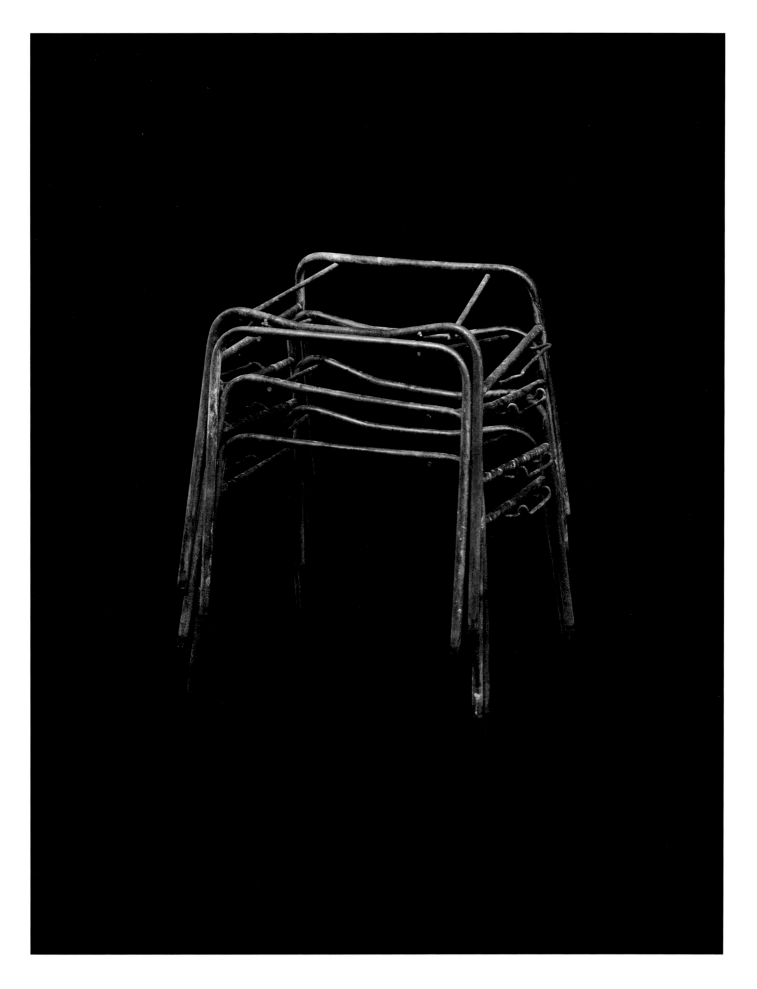

Four stools Collected 28 October 2016

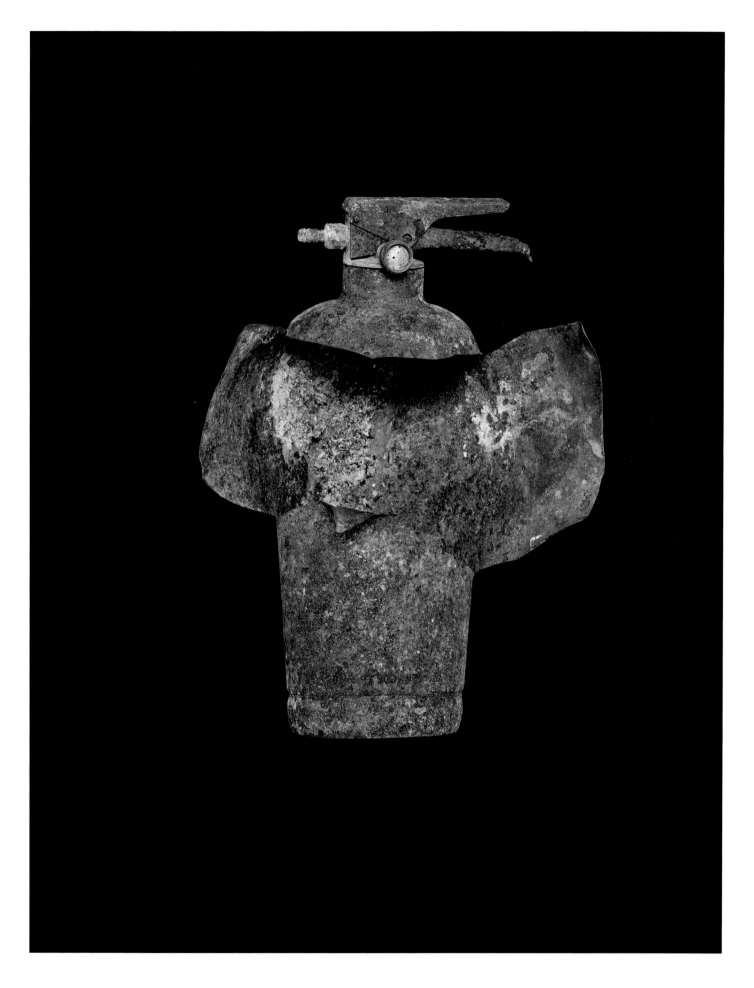

Exploded fire extinguisher Collected 28 October 2016

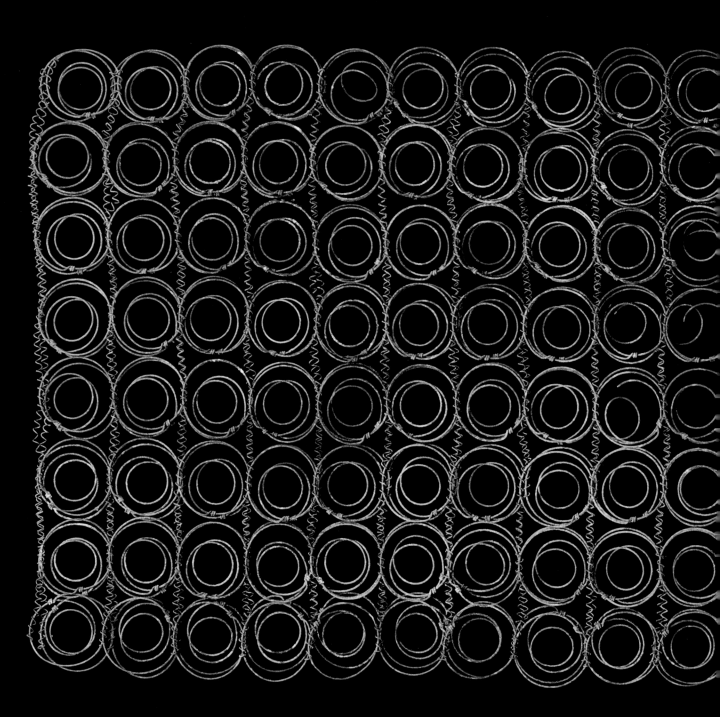

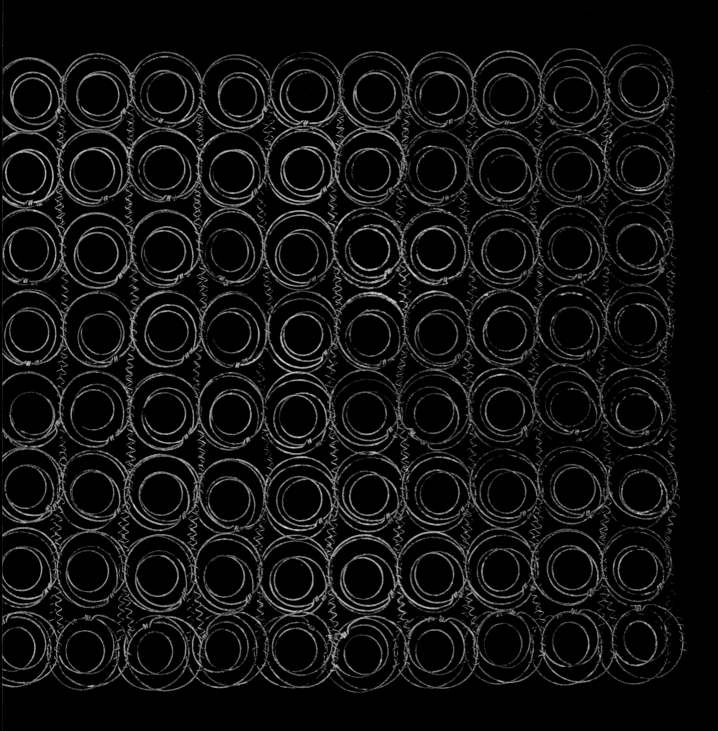

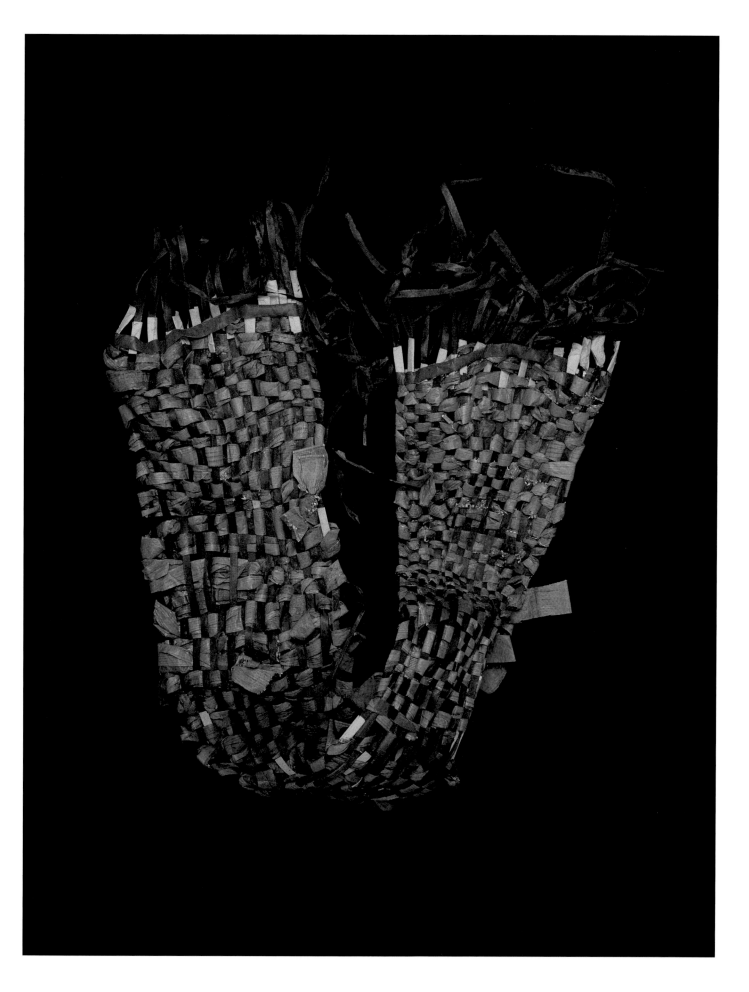

Hammock Collected 27 October 2016

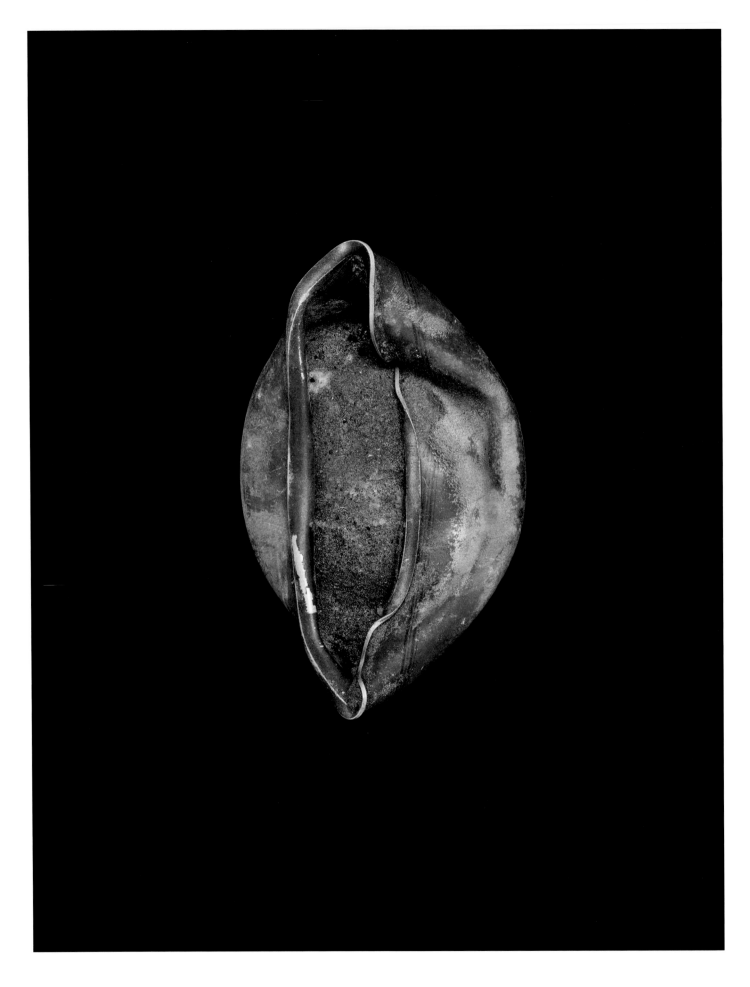

Saucepan Collected 28 October 2016

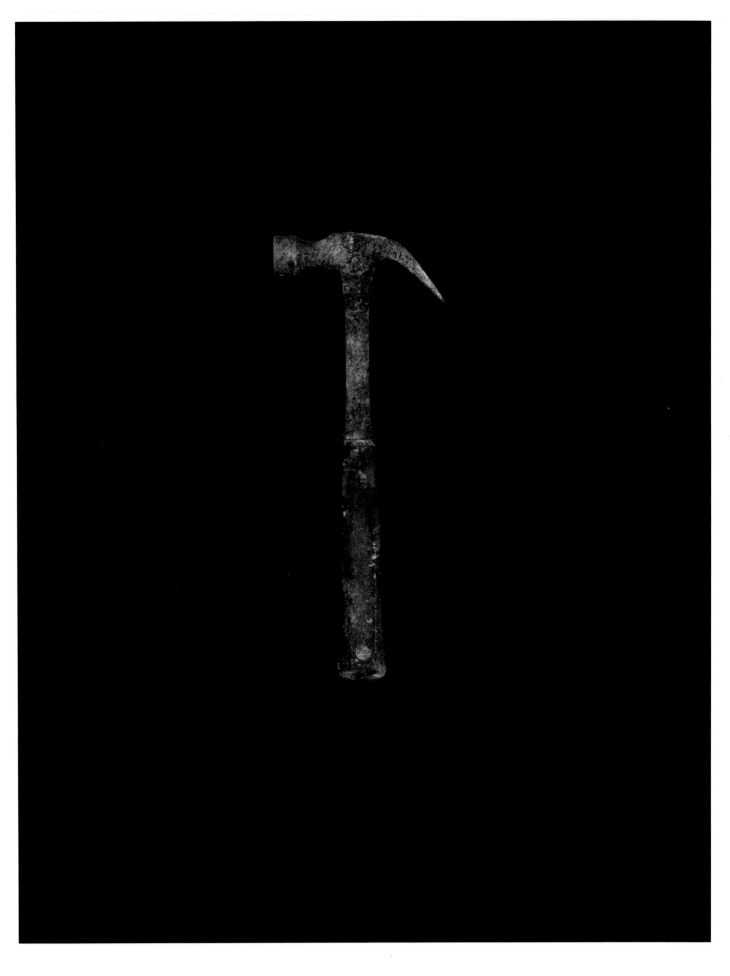

Hammer Collected 28 October 2016

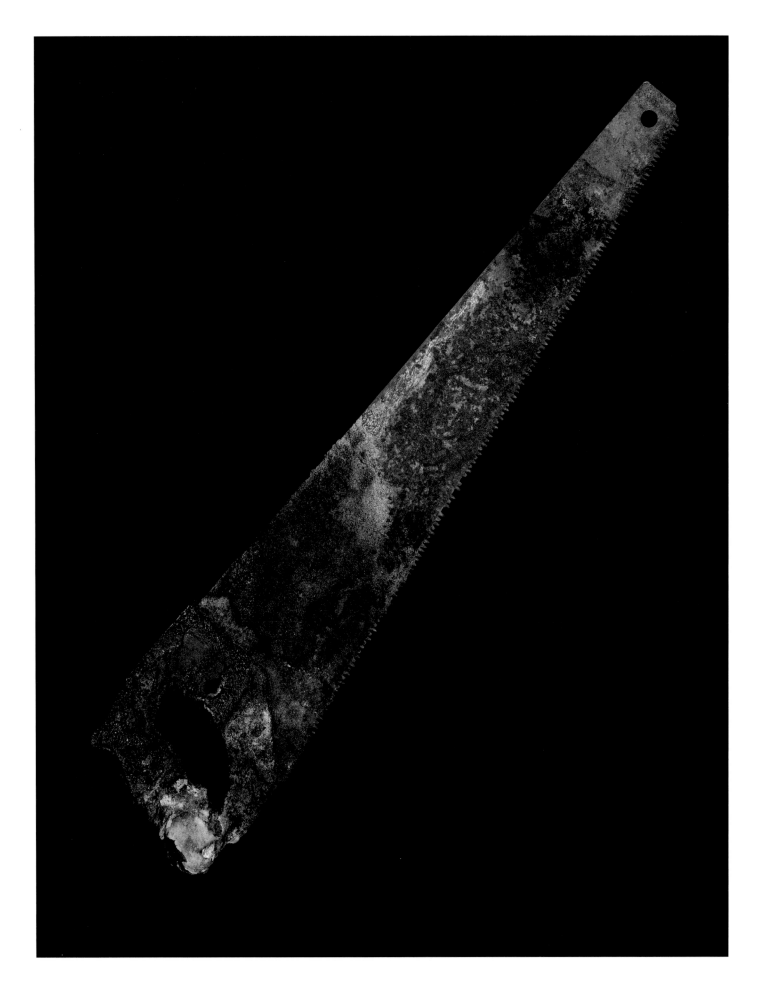

Saw Collected 21 May 2016

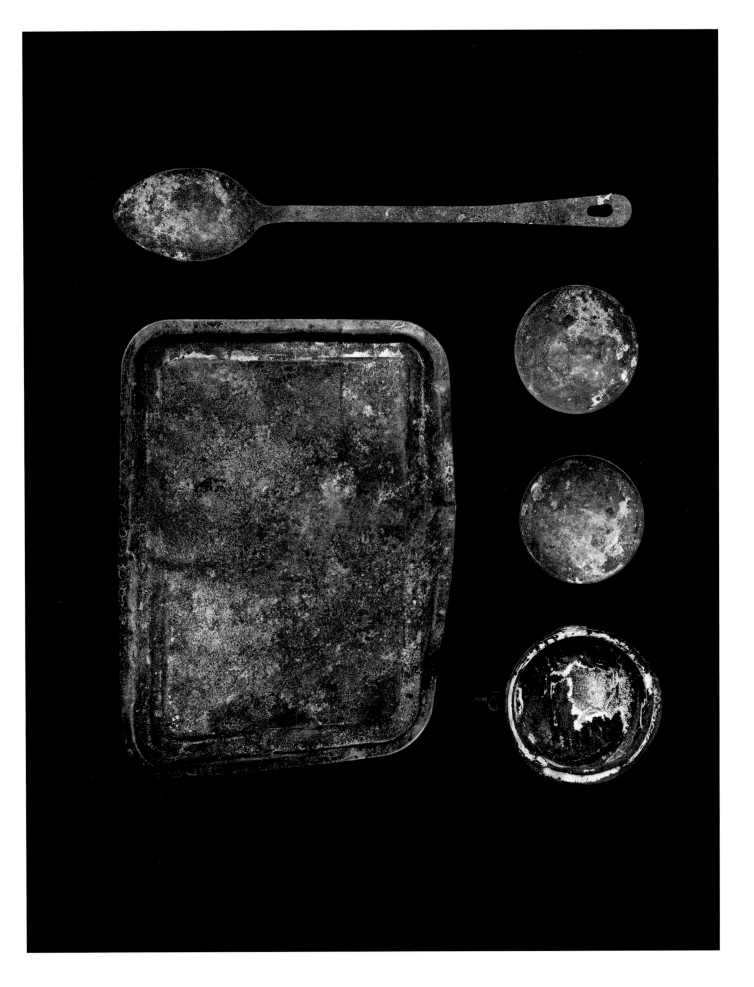

Kitchen utensils Collected 27 October and 28 October 2016

Account by Shaheen Ahmed Wali

My younger brother was riding with me in my tanker. A neighbour from our village was also riding with us. After about two hours, he called out, 'Stop, I must pick up a friend.' The friend was covered with a big blanket, like Afghans use in winter; under it was a Kalashnikov. After some minutes of driving, he put the gun to my head and ordered, 'Turn to the right.' I had to do what he said. I turned into a street and through the gates of a big villa.

There were twelve persons with heavy weapons there. Their commander said, 'I am giving you a box; take it to my men up the road.' I said, 'What's in the box?' He replied, 'Weapons and explosives.' I said, 'I can't do it.' He said, 'Ok, I will shoot your brother.' The eyes of my brother were full of tears; he was like a child to me. I said, 'I will do it.' They put the box in my tanker. That was the last time I looked towards my brother's eyes; he was just looking at me.

I was worrying, 'What should I do?' I thought, 'I can't kill a lot of people.' So I told the police at the checkpoint everything. They took four rangers and returned, with me, to the Taliban villa. After twenty minutes' fighting, they took over the villa. When we went inside, I saw my brother lying on the ground. They had shot him in the head. I cried and shouted, 'What has happened with my brother!' That was a very panicky and hard time for me, the worst in my whole life. I called my father: 'Come and take my brother's body.' My mother sobbed, 'Why did you take my son with you?' She hugged me and cried the whole night. Our whole family was very sad about my brother.

The Taliban commander called and said, 'We killed your brother. You made a problem for us, and we will do the same to you.' I was very scared. My father told me, 'Now you must leave the country.' I left my wife, my five kids and my parents. We sold our family property and I deposited $10,000 with the agent for taking me to Europe. So I started my journey.

Near the Turkish border, the agent said, 'We have 15 minutes' break and after that, we have to climb the mountain.' It was very steep. We started climbing. The agent was shouting at the women and children because they couldn't climb like us men. The agent pointed his gun and said, 'Because of you people I can't carry on...' so some of us men decided to help the women and children. I carried a baby and a bag.

With difficulty, we reached the top of the mountain. We took a short break there. After that, we started going down; it was very difficult. Suddenly, some people started shouting, 'A guy has fallen off the mountain!'

I told the agent in Persian, 'A man has fallen down.' He said, 'Forget about him.' I said, 'But he was our friend.' He pointed the gun at me. 'You want me to throw you down like him? Just walk!'

At last we reached the Jungle, in Calais. It was very cold so I found a volunteer who gave us a blanket and a tent. In the morning, I awoke to a new world: many people from different countries, a lot of volunteers helping people. To be honest, I liked it, and I spent the whole day walking about.

I asked a guy, 'How can I get to the UK?' He said, 'It's very difficult. There is an agent, you have to talk with him.' The agent said, 'Pay €500'. I didn't have that much money. 'How much can you pay?' 'Only €200.' 'OK. Be ready tonight. We will close the autobahn and then my man will get you onto the container so you can hide there. There are two police check posts: the French and the British. When you have crossed these two, the container will drive onto the ship. After some hours, you will be in England.' It sounded very easy.

That night, the agents made fires on the road to stop the container trucks and broke the locks on some of them. They shouted, 'Get in!' We hid under the cartons and they locked the door from outside. Then the truck moved towards the UK.

At the first check post, the French police had dogs. They found us and arrested us and kept us overnight. Then they took us to the police station. They wrote down our names and released us. We came back to the Jungle and slept all day.

In the evening, they assembled the group again. But I fell as I tried to climb into a container and I broke my coccyx. It was so painful I couldn't walk, so some guys carried me back to the Jungle.

In the morning, I went to the hospital. The doctor told me, 'You have to take care of yourself. You will suffer this pain for a long time, even for your whole life.'

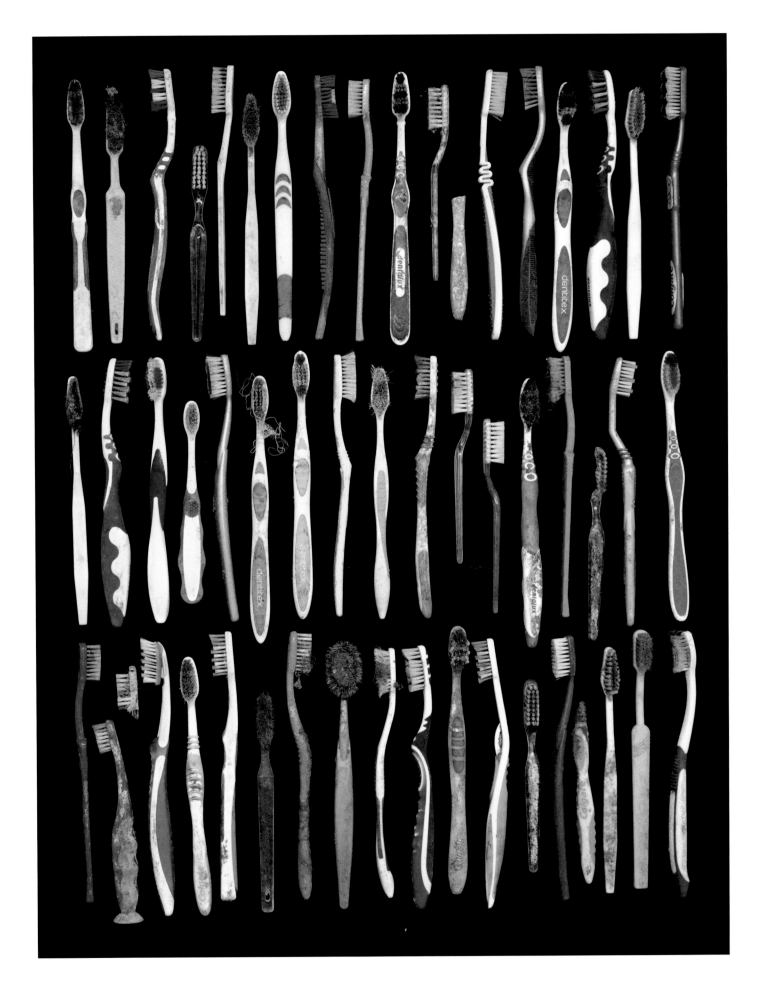

Fifty-four toothbrushes Collected 21 May, 15 September, 27 October and 28 October 2016

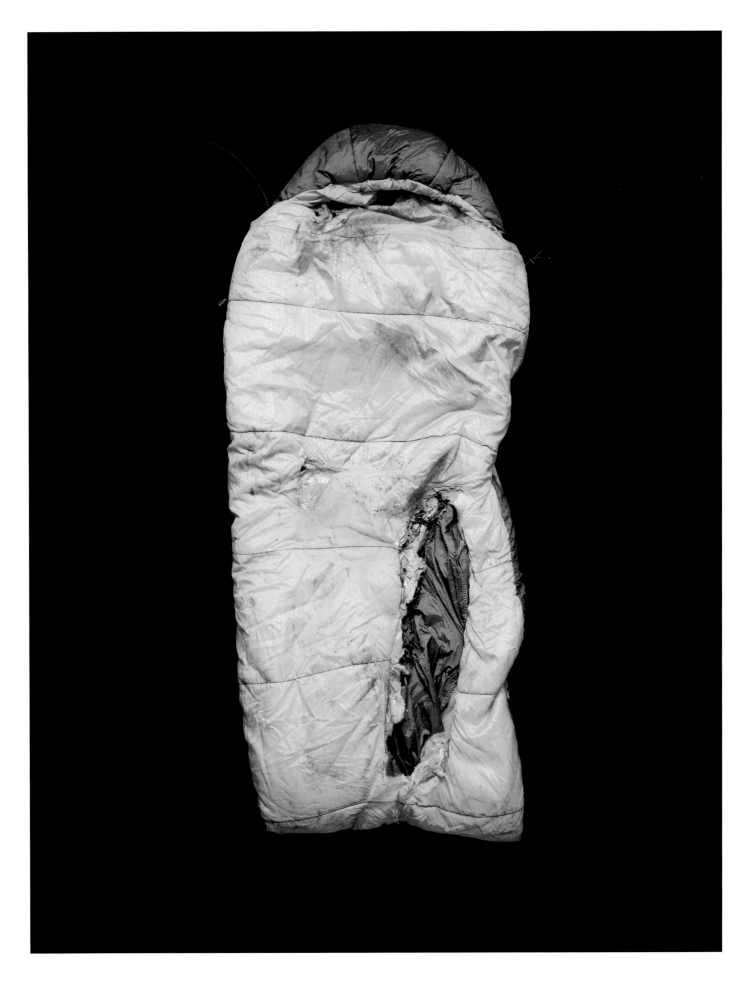

Sleeping bag Collected 15 September 2016

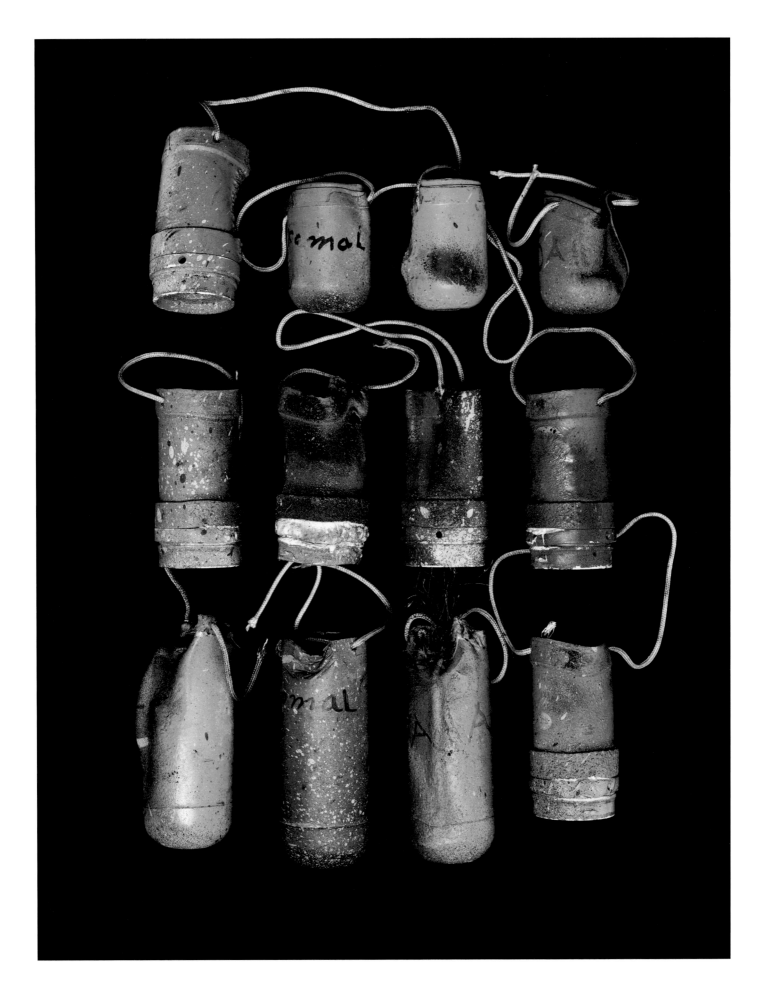

Decorated tear gas canisters Collected 28 October 2016

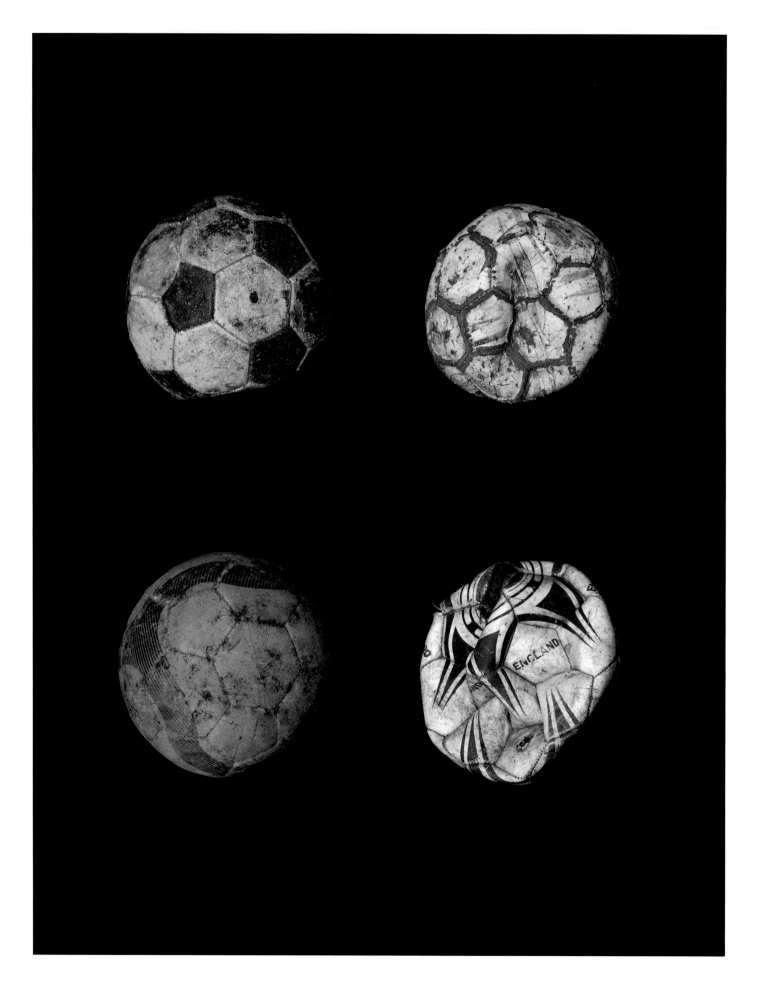

Footballs Collected 21 May, 15 September and 28 October 2016

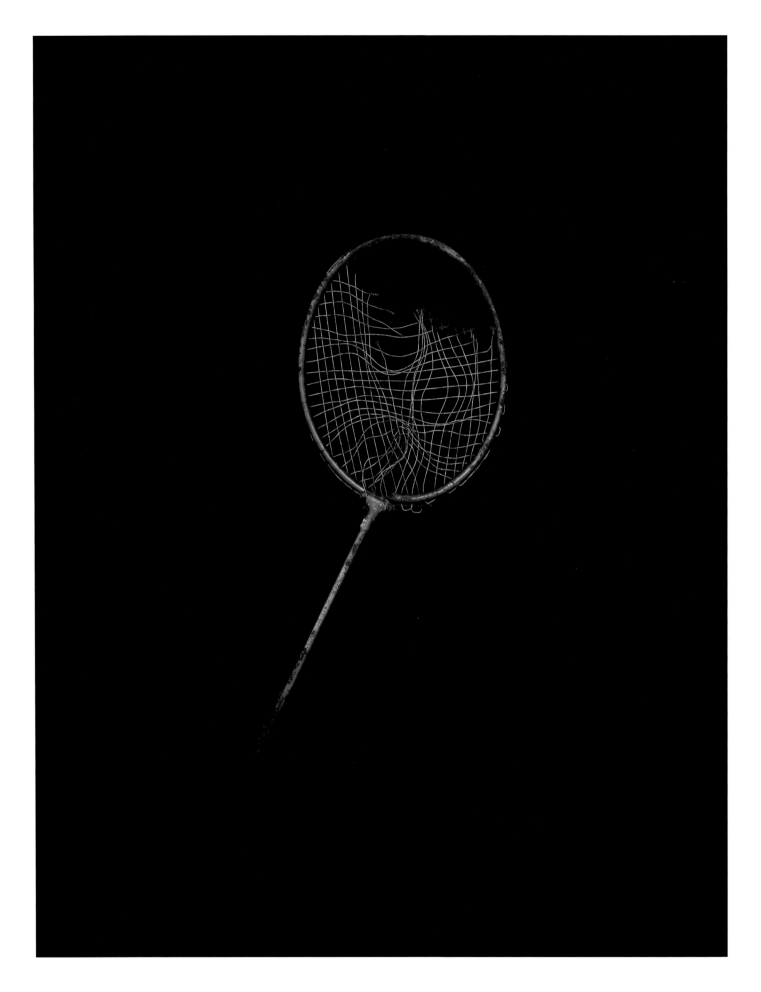

Badminton racket Collected 21 May 2016

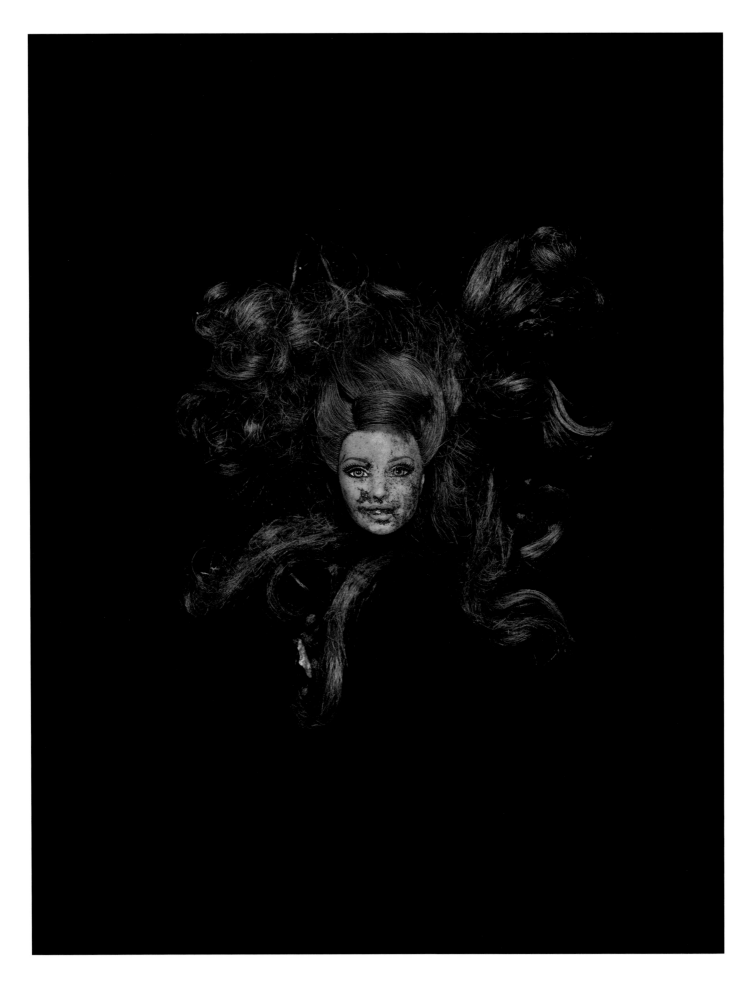

Doll's head Collected 28 October 2016

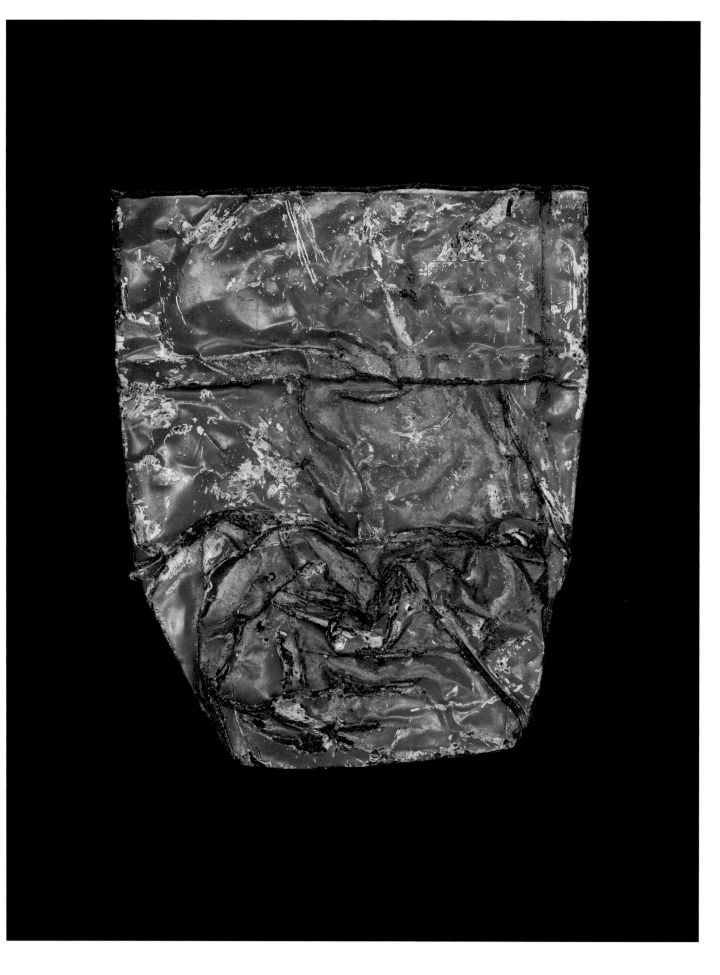

Squashed barrel Collected 31 March 2016

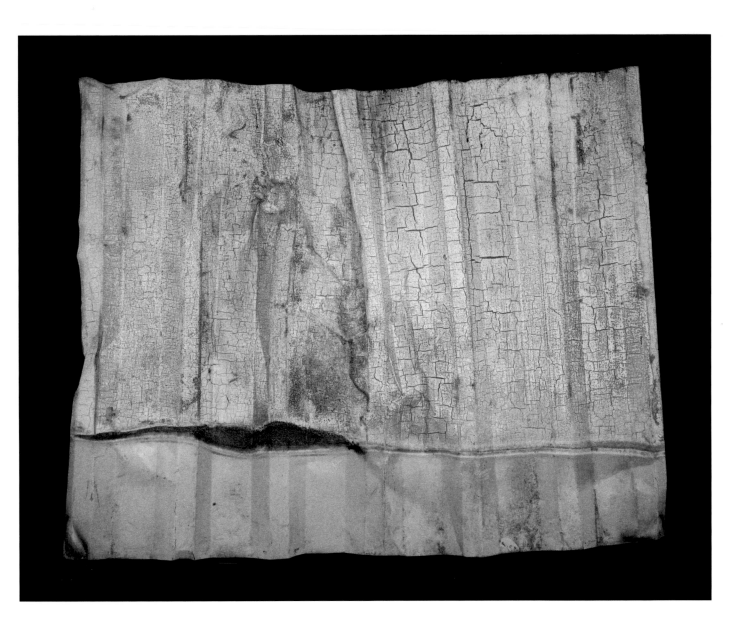

Corrugated iron sheet Collected 14 October 2016

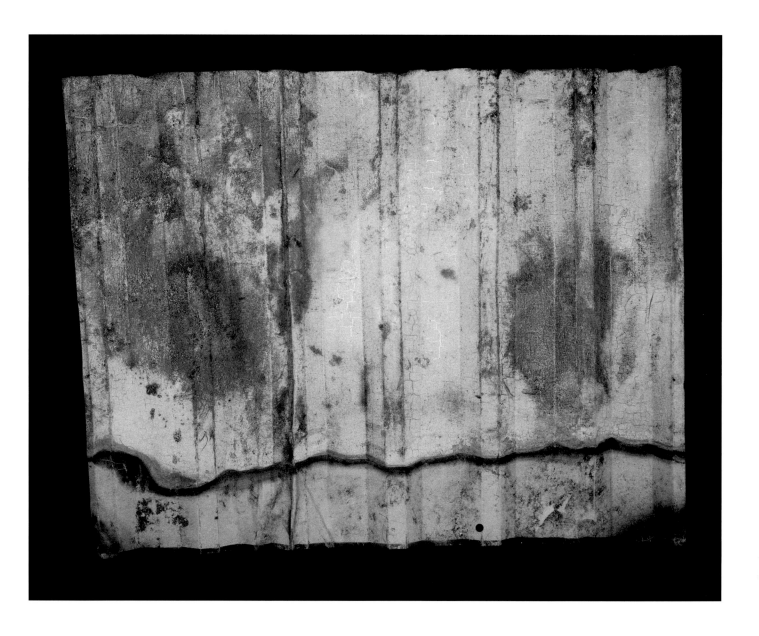

Corrugated iron sheet Collected 15 September 2016

Forensics
(photography in the face of failure)
Dominique Malaquais

Breaking point(s)

Calais Jungle, May 2016. An itinerant circus pulls up, followed by a Christian procession trailing a healing donkey. The southern half of the camp has recently been reduced to rubble, set alight and bulldozed. The stench of smoke lingers and water pools. Riot police patrol. Gideon Mendel raises his camera to photograph the donkey. A man confronts him: "You fucking photographers! You come here and you take our photographs and you tell us that it is going to help us, but nothing changes. The only person it helps is you".

Over the many years of its on-and-off-again life, from the early 2000s to late October 2016, the Jungle has attracted many cameras. In its final months, it is awash in lenses. Journalists, TV crews, government workers of various descriptions, NGO staffers, human rights activists, independent filmmakers, artists: all determined to document the demise of Western Europe's most notorious refugee camp. Images of Calais splash across the front pages of newspapers and flood the web. In waves, exhibitions are planned and photo books go to print.

The overwhelming majority of images shot are of people. The focus is on bodies – on facial expressions and gestures, on poses struck in the midst of an apocalyptic landscape. In many cases, the goal is to humanise the camp's inhabitants: to coax viewers into seeing them as individuals rather than as an undifferentiated mass, prompting concern and, where possible, empathy. In other instances, the purpose is less laudable. Right-wing news organisations alternately seek to instil fear – THIEVES! RAPISTS! TERRORISTS! – or crow as men, women and children stream out of the camp, their exit overseen by police in full body armour. Brandishing images of the exodus, politicians claim victory in staunching the flow of "migrants".

Whether any of this has anything other than the most fleeting effect is unclear. The argument is by now an old saw: bombarded with visuals at every turn, we have become inured to the violence shown, no matter how horrific, and, simultaneously, we have become insatiable. No one image will satisfy us. We have morphed into ghoulish voyeurs. Post Abu Ghraib, we no longer see. Our attention span

has shrunk so short that not even Aylan Kurdi's tiny drowned body or the dazed and bloodied gaze of Omran Daqneesh can sustain our interest for more than 24 hours. On the rare occasions when our attention is held, it is for the wrong reasons. Deluged by fake news, we have lost even the most basic ability to read images. Thus the now infamous UKIP "breaking point" poster showing an interminable queue of refugees: shot on the Croatia/Slovenia border in 2015, the photograph at its centre was misread by millions of anti-EU voters as a 2016 depiction of asylum seekers clamouring to enter the UK.

In the face of such an onrush of images glanced at, misconstrued and cast aside, the question arises of what to photograph so as to bear witness – or, indeed, of whether to photograph at all. The query is hardly new. Following the Holocaust, the Vietnam War, the hell that descended on the Balkans in the 1980s and Sudan in the 1990s, the Rwandan genocide, and now the bombing to shreds of Syria, countless photographers, theorists and critics have wrestled with its implications.

After the donkey, Mendel puts down his equipment. He will not be taking any pictures at all – not here, not now.

Forensics

Eschewing images, Mendel begins collecting evidence: remnants of lives that once animated the southern section of the Jungle. Sifting through the camp's debris, he gathers charred, crushed, crumpled and waterlogged remains of clothing and footwear, children's toys and books, sports equipment and playing cards, carpentry tools, construction materials, furniture, bedding, personal hygiene products... He amasses piles of tear gas canisters and shotgun shells, the latter a throwback to days before the refugee crisis, when hunters came looking for birds in the woods surrounding Calais. As summer gives way to fall and the destruction, to great fanfare, of the northern half of the camp, his stash of abandoned objects grows. From a photographer he has morphed into a forensic scientist, in quest of clues to a crime.

Away from Calais, each discarded fragment is photographed. Shot from above using a Linhof field

camera attached to a copy stand in the controlled environment of a professional studio, flooded in light precluding any hint of shadow or depth, Mendel's finds lie flattened against the picture plane of an ink-black digital background. Items appear singly, in pairs, in rows. Insects come to mind, pinned to a virtual corkboard by an entomologist documenting endangered species, or vestiges assembled by archaeologists accounting for a blighted civilisation.

An air of dispassion prevails. A singed teddy bear, the rusted remains of a mattress, a flattened barrel: no object is given greater scrutiny than another. Spent cartridges, toothbrushes, gloves, trainers, sandals and flip-flops are set side by side in noncommittal lines. Every effort is made to blunt the sleekness of their design, lest the eye take pleasure in the patterns and colours their layouts are likely to produce.

Contra-aesthetics

Mendel's goal is to de-aestheticize the encounter with refugee bodies, for in aesthetics we find respite. Having made it impossible for us to retreat into gazes and gestures that the discourse of human rights has programmed us to see as reflections of our own, he challenges us: will we insist on anthropomorphising the shoes, bonnets and shirts, the bits of burnt blanket and rusted chairs he has collected? Of course we will. A significant part of the work's heft comes precisely from this: the danger it knowingly runs of being appropriated to such facile ends. So too its problematic flirtation with beauty. For the images, designed to be blown up to a metre and a quarter, are incontrovertibly appealing. The deep black of their background is properly lush, the lighting worthy of the finest advertising shoot. They are desirable in the extreme.

All of this is intentional: the photographer is at war with his own practice. Every image is a head-on collision with the failure of photography – and of art more generally – to cause anything but the tiniest ripple on the surface of our collective disengagement. Each is an admission of radical defeat.

Intentional as well is the collision with Euro-American traditions of collecting. The praxis of compiling physical evidence to account for "others",

making "sense" of their difference and, thereby, of the collector's power to examine, name, bracket and administer, has a long and violent history. Phrenology, criminology, ethnography, anthropology, museology: structured around the collection of professedly objective data, each of these disciplines and others still – the pseudo-science of eugenics among them – has, it is well known, at various times in the last two centuries played a critical role in the subjugation of individuals, communities and entire peoples. Calling upon the dual "arts" of gathering proof and photographing it – mainstays, both, in the documentation of variance – in no uncertain terms Mendel references this past and, in the era of Trumpism ascendant, its savage present.

Waist deep

Mendel does not stand at a remove. He wades into the morass, dragging us in as he goes. Our refusal to follow (many will declare this work too cerebral, too cold, too easy, too hard) – or, worse, our acquiescence (for those of us who claim an understanding of the images and, on such grounds, choose to write about them, to catalogue, exhibit, acquire and collect them) – will, in equal measure, be failures.

Dzanghal allows no room for ethical manoeuvre. None of us walk away clean.

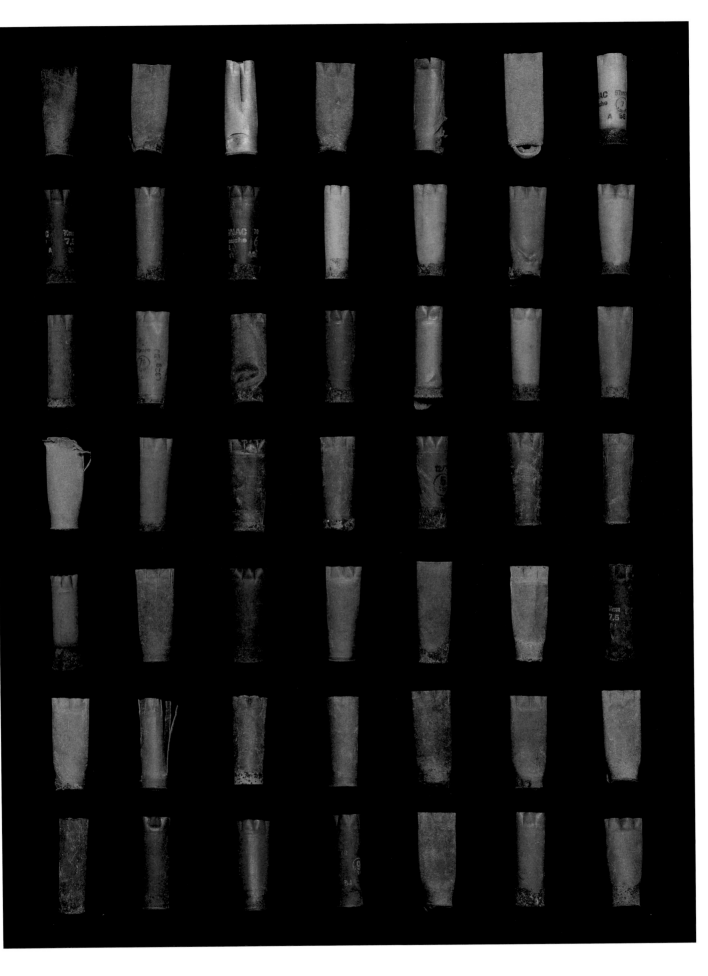

Forty-nine shotgun casings Collected 21 May, 15 September, 27 October and 28 October 2016

A planet without a visa
Paul Mason

For the past 30 years we have lived amid an accelerating global movement of people, ideas and things. Of these, it is people that have enjoyed the least freedom; ideas and things have moved a lot more easily than human beings.

Since 1971, the value of world trade in merchandise has risen 44-fold – from $336 billion to $16 trillion. Internet traffic has risen from 100 gigabytes a day in 1990 to 20,000 gigabytes per second now. By contrast there are today 243 million migrants in the world today, and according to the United Nations Population Division that is less than double the number registered in 1990 and only three times what it was in 1971.

Behind these bare facts lies the whole drama of the second great epoch of globalisation. Cross-border trade exploded; borders in the realms of language and ideas were obliterated by digital communications. But human beings lagged behind.

And those who wanted to move the most – the refugees – were the least able to. They were forced to trudge, creep or swim around physical mechanisms of coercion: the border post, the patrol boat, the razor wire fence.

To utter the word "migration" in a public conversation in late 2016 – after the Brexit vote and Donald Trump's victory, and with the presidential election imminent in France – is to trigger dismay, frisson, a desire to change the subject.

To understand why we should not change the subject, we need only to look at the long-term economic forecasts produced by the global think tank, the Organisation for Economic Co-operation and Development (OECD).

In 2010, the working-age population of the developed world stood at 1 billion. By 2060, in order to stave off widespread country bankruptcy, the OECD says the working-age population in the developed world needs to rise by one-fifth: to 1.2 billion people. Since the birth rate is too low and people are living longer, most of the extra 200 million will have to come from migration.

By 2060, the Eurozone, says the OECD, must absorb another 50 million migrants, the USA more than 50 million, and the rest of the developed world another 30 million.

If the migrants do not come, then the working population will be strangled by high taxes, or their public services will be destroyed, or many state treasuries will go bust. This is not conjecture: it is a peer-reviewed prediction by one of the few global institutions qualified to make it.

Writing in 2013, the OECD identified a danger to its projection – but the wrong one. It feared wages in the developing world would grow so fast that the migrants might not come. Today we can see a much clearer danger: that the host populations of Europe and North America will not tolerate their arrival.

Indeed, there is now a danger that democracies – and the multilateral treaties they have signed – will begin to implode under the strain of a failed economic model, and that the political sickness of xenophobia and racism will dominate the agenda.

It is in this context that we must view the bottlenecks of misery we have created for refugees: the Calais Jungle, now obliterated; the decayed factory in Patras, Greece, where I saw stranded migrants washing in rainwater in 2012; the makeshift camps that still exist along razor wire fences in the Balkans; and the vast pool of misery along the North African coastline, which is likely to be the migration frontline of 2017.

If the developed world needs 130 million extra migrants over the next 50 years, it is economic folly to wage war on refugees. On top of that, the fence line deterrence being practiced against them breaks every international convention signed since 1948.

Refugee numbers stand at 21 million worldwide. Their destinations remain concentrated in the Middle East, according to the United Nations High Commission for Refugees. Turkey hosts 2.5 million, then come Pakistan, Lebanon, Iran, Ethiopia and Jordan.

Last year, just 32,733 out of the world's 21 million refugees managed to reach the UK and claim asylum. Of these, as per the UK Parliament's research briefing, just 11,421 were granted asylum or another form of permission to stay.

The UK government, in an attempt to deter irregular entry, refused to take its share of the 1 million Syrian refugees who fled to Europe last year. Instead it promised to resettle 20,000 Syrian refugees from camps located in the Middle East

by 2020. Going by the official figures of September 2016, just 4,500 had arrived.

The logical thing to do now is restore public consent for economic migration and recognise the inalienable right of refugees to claim asylum. But political systems are gripped by illogic. And even the logical is difficult to do in practice.

By 2016, the global system had begun to crack. Currency wars simmered between China and Japan. One million Syrian refugees were unleashed by Turkey as a bargaining chip with Europe. Then came Brexit. And then Trump.

When the USA – the country that designed globalisation and has benefited most from it – votes against globalisation, that is the sound of something big fragmenting.

The neoliberal system was supposed, in Francis Fukuyama's famous formulation, to herald the end of history; to make the earth – economically speaking – 'flat', or, as Bill Gates put it 'friction free'. Nation states were supposed to become mere local branches of a cross-border elite; national identities were to be substantially eroded by the all-powerful franchised megabrands. But all this turned out to be temporary. It lasted less than 30 years.

The era that began in 1989, with the fall of Communism, and which is ending now – as Donald Trump proclaims the reversal of global trade – looks in retrospect fundamentally anti-humanist, for all the public celebration of individuality and the self.

Neoliberal capitalism treated human beings at work as abstractions: as name badges, as human resources, as people whose rights and duties as citizens were primarily economic, not social. It said (via subtext) to the old, industrial communities of the developed world: we do not care who you are or where you came from. What happened in your brick-and-cobbled streets 50 years ago is your concern, not ours. Ours is the world of the value chain, the profit margin, the anodyne global brand. To us, you are simply human capital.

Fatally, those who designed and implemented this free-market system portrayed the economic migrant as the ideal subject. A person already uprooted, made pliant by rootlessness and dislocation. An unwilling tool of the exploiters,

but a tool nevertheless, that could be used to grind down wages, conditions and traditions.

Sure, we are dealing with white racism, the dormant fascism lurking within European Christianity and the xenophobia of small communities under social stress. But the longer I have reported the rise of anti-migrant racism, the more I am convinced that it is this, the economic subtext of globalisation, that has fuelled it.

If I am correct, then to restore consent for high migration does not mean demanding major changes in the behaviour of migrants. It demands, rather, major changes in the behaviour of employers, politicians and economists. They need to kick their addiction to low-wage, exploitative business models. They need to stop viewing citizenship as involving purely economic rights and duties. They need to rediscover the beauty of locality, tradition and work-based lifestyles. They need to stop celebrating the atomization of society.

To restore consent for economic migration may mean giving the existing population more control over who comes, and in what order. But in the long run, this will be only the semblance of control: the fact that the USA, with the strictest skills-based visa system in the developed world, contains 11 million undocumented migrants (according to the Pew Research Center) makes it clear that control is always relative.

This re-introduction of humanism into economics matters to all of us. If technological progress unfolds as predicted, with rapidly increasing automation by the mid-21st century, then we all face the loss of identities based on work. The lawyer risks being supplanted by artificial intelligence just as factory workers were supplanted by an automated process. We should heed the lessons of the past 30 years. Free-market economics destroyed work-based identities selectively, mainly for those it needed to defeat: the unionised workers and the cohesive communities that could stage resistance. All it left them were identities based on place, culture, ethnicity or religion. These – as we are now witnessing – can become destructive.

To restore consent for high migration, we must dissociate the movement of people from the war of the rich against the poor. The movement of people

must – just as the movement of ideas and things did – benefit us all. And within that solution, we should recognise – as international law does – the inviolable status of the refugee.

Refugees are not just treated like dirt in the asylum systems of the West. They are forced to live in dirt. Their possessions become mixed with the dirt, just as they are amid the charred ruins of that pop-up Troy, the Calais Jungle.

Refugee numbers explode when states implode. Refugees move when once-stable ecosystems, economies and political spaces become inhospitable. The lesson is not to cling to stability: it cannot exist in a world of poverty, dictators, racial injustice and climate change. Instead, the solution is to manage the instability: to impose international law, norms of behaviour and common rules on the governments and agencies that deal with refugees. Or, rather, to re-impose them – because they are all there in the treaties and conventions our states are currently flouting.

We have lived in an economic system capable of multiplying global trade in goods, services and ideas at speeds beyond imagination; capable of encouraging 240 million people to cross borders legally to seek a better life; capable of understanding, theoretically at least, the need for another 130 million to do the same, as identified by the OECD.

So why did we get so wound up about 21 million people in the greatest need, pushed up against the razor fences and the tear gas, people who simply wanted to escape?

In a free-market system, the refugee is viewed as an anomaly because their motivation is not primarily economic. Refugees move for reasons to do with the whole human being: their sexuality, psychology, nationality, gender, religion, skin colour or language.

An asylum claim is the demand to be accepted into a community, not an economy. It is the demand for one's whole story to be understood, not one's economic function.

That is why, for the past 30 years, asylum has been stigmatized.

In Patras in 2011, I met a man from the Maghreb, his arms scarred from clashes with local fascists and police. His clothes smelled like yours would if you sat next to a fire made of rubbish every night and never changed them. He was carrying in his pocket Sartre's book *Les Mots*. He carried it in order to convince us that he was a sociology graduate – which he was not – and a secularist, which he was.

The Greek state spent three years, including months in a detention centre, stopping this secular, educated man moving from Greece to France. In the end he accepted deportation to his country of origin.

He is now an undergraduate in his own North African country, and understands Sartre even better than he did while sleeping in the wrecked factories and ditches of Greece. He is still unable to leave from his country of origin; still facing the same combination of poverty and restrictive laws that made him flee in the first place. A "failed asylum seeker". If you would like to hire him or invite him to study sociology at your university, I can connect you. He is my friend.

The title Dzhangal refers to a Pashto word meaning 'This is the forest', the origin of the contentious term the 'Jungle'.

Acknowledgements

This project would not have been possible without the practical and creative input of Alice Mann. Her fastidious attention to detail was a key element in this forensic response to the found objects. Metz+Racine and Marcus Lyon welcomed me into their photo studios to shoot these images. Corinne Squire from the Centre for Narrative Research at the University of East London invited me to teach in the Jungle camp and inadvertently started this process. Gary van Wyk and Lisa Brittan from Axis Gallery along with Stu Smith helped me develop my visual engagement with these items. Karin Bareman and Mark Sealy from Autograph ABP helped curate and produce the first exhibition of this work.

Further thanks to Bobby Lloyd and Naomi Press from Art Refuge UK, Jungle Books Library, Babak Inaloo, Adam Goodison, Kate Edwards, Gareth Williams, Benjamin Youd, Joe Briggs-Price, Crispin Hughes, Chelsea Agyemain, Marie Godin, Mikhael Subotzky, Annie Holmes, Kristian Buus, Barbara Metz, Mike Kemp, Ferdy Carabot, Christine Eyene, Amelia Gentleman, Dominique Malaquais and Paul Mason. Finally, thanks to the many remarkable refugees I met in Calais whose stories and faces will remain with me always.

Gideon Mendel is represented internationally by Axis Gallery NY & NJ.

Dominique Malaquais is a senior researcher at Centre National de la Recherche Scientifique (CNRS) and co-director of SPARCK (Space for Pan-African Research, Creation and Knowledge).

Paul Mason is a columnist at *The Guardian* and the author of *Postcapitalism: A guide to our future*.

The accounts and poetry in this book, from past residents of the 'Jungle' camp, are drawn from *Voices from the 'Jungle': Stories from the Calais Refugee Camp*, to be published by Pluto Press in April 2017 (ISBN 9780745399683). The book was written by 22 authors from a wide range of backgrounds who lived at the Calais camp between 2015 and 2016. The extracts in this publication are by Babak Inaloo, Shaheen Ahmed Wali, 'Africa' and 'Mani'. Some of the writing was produced for the 'Life Stories' accredited university short course, run three times at the camp by the Centre for Narrative Research, UEL, as part of the 'University for All' project led by Corinne Squire. Other writing was generated within the Centre for Narrative Research's 'Displaces: Multimodal narratives' photography workshops with Gideon Mendel and Crispin Hughes. Additional text editing for this publication is by Annie Holmes and Gary van Wyk.

This project was developed with support from Autograph ABP.

First published in 2017 by
GOST Books
8a West Smithfield
London EC1A 9JR
info@gostbooks.com
gostbooks.com

© GOST Books
All photographs © Gideon Mendel
Text © Dominique Malaquais, Paul Mason, 'Africa',
Babak Inaloo, 'Mani', Shaheen Ahmed Wali
Edited and designed by GOST
Allon Kaye, Claudia Paladini, Ana Rocha, Justine Schuster

Printed in Italy by EBS

British Library cataloguing-in-publication data. A catalogue record of this book is available from the British Library.

ISBN 978-1-910401-15-6

GOST